IMAGES
of America

IRISH MILWAUKEE

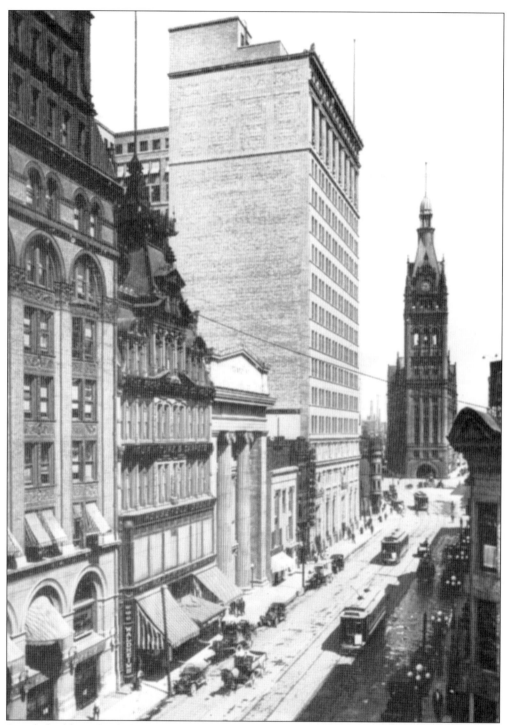

Stately buildings lead along East Water Street to the Milwaukee City Hall in this early 19th century scene of downtown. By this time, Irish business leaders were already making their mark on the city with their warehousing, retail, transportation, service, and port operations. (Photo from *History of Milwaukee*, 1922, from the Sheldon Solochek collection.)

IMAGES
of America

IRISH MILWAUKEE

Martin Hintz

ARCADIA

Published by Arcadia Publishing
Charleston SC, Chicago IL, Portsmouth NH, San Francisco CA

Printed in the United States of America

Library of Congress Catalog Card Number: 2004272845

For all general information contact Arcadia Publishing at:
Telephone 843-853-2070
Fax 843-853-0044
E-mail sales@arcadiapublishing.com
For customer service and orders:
Toll-Free 1-888-313-2665

Visit us on the Internet at www.arcadiapublishing.com

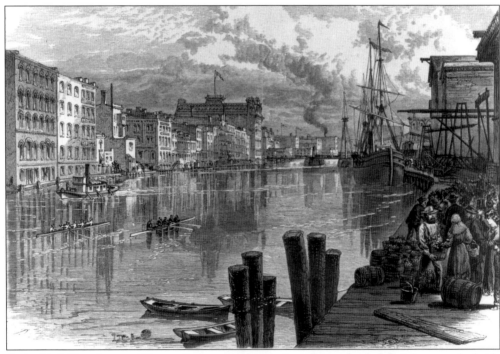

Arrival in Milwaukee could be confusing to new arrivals as they unloaded their baggage dockside along the Milwaukee River. Thousands of Irish poured through the port to find homes in the city and on the western frontier. (Sketch courtesy of the Milwaukee County Historical Society.)

CONTENTS

ACKNOWLEDGMENTS

The author wishes to thank Matt Blessing, archivist at Marquette University; Tim Carey, archivist at the Milwaukee Archdiocese; archivists Steven Daily and Kevin Abing at the Milwaukee County Historical Society; the staff at the Milwaukee Public Library Great Lakes Collection; historian Jerry Carroon; attorney-genealogist Tom Cannon; photographers John Alley and the late Bob Higgins; Jean Bills of Celtic Women International; John Maher, manager of the Irish Cultural & Heritage Center; Barry Stapleton, archivist, Milwaukee Irish Fest; Lois Martin and Carol Will, archivists for the Daughters of Charity of St. Vincent de Paul; Carrie Bohman, archivist at the Wisconsin Veterans Museum; author/historian John Gurda; the late great *Milwaukee Journal* reporter Robert W. Wells; the Emerald Society; the International Institute of Wisconsin; the gang at the Ancient Order of Hibernians; the scholars of the Irish Genealogical Society of Wisconsin; the helpful folks at the Milwaukee Archdiocese cemeteries; Mike Neville, Jane Russell Holzhauer, Bill Sullivan, Elizabeth M. Boemer, and the many other individuals and families who rooted through shoe boxes under their beds, rummaged in closets, opened scrapbooks and shared memories of forebears.

INTRODUCTION

Milwaukee's Irish can claim a long and distinguished heritage throughout Beer City's history. One needs only to thumb through the telephone book to count the extended families of Finnegans, Dooleys, Nevilles, Cannons, Sheehans, Russells, and Malloys who call the Greater Milwaukee community their home. Names with "O" and "Mc" are as abundant as woodland mushrooms around the Jeremiah Curtin house. Like that tiny building in Greendale, the first stone home built in Milwaukee County, the Irishness of the Milwaukee area has remained rock-strong.

However, the Irish were less heralded than other groups when they first arrived in Wisconsin. Yet the fact that they could speak English gave them a leg up on some of the other ethnic groups flocking to America. This—plus grit, hard work, and creativity—allowed access to jobs, which in turn gave economic independence and encouraged a swift upward mobility within Milwaukee's power system. For instance, Irishman Thomas Gilbert was elected village president in 1844, two years before Milwaukee became incorporated. The list of judges and other community leaders over the ensuing years with a touch of the Gael about them still seems endless.

One prominent Irishman who came to Milwaukee prior to the Civil War was John Gregory, born near Listowel, County Kerry, in 1783. Arriving in the United States in the heady year of 1849, Gregory and his partner David Power were the best known of several immigration agents who helped lure more of their countrymen and women to Wisconsin. These officials represented organizations such as the American Emigration Co-operative Association, known in Milwaukee as the Irish Emigration Society. The organization opened its doors on August 18, 1849, across from the United States Hotel on the southeast corner of Clybourn and North Water streets. They often helped pay for passage, buy land, and secure jobs, as well as performed a multitude of related tasks to acclimatize the newcomers to the ways of Wisconsin.

By 1850, through such efforts, 21,403 Irish had moved to Wisconsin with 4,500 living in Milwaukee County. A number had lived elsewhere in the United States or in Canada prior to coming to the Badger State. Many were of the opinion of Michael Russell of Templemore, County Tipperary, who arrived in Canada after a five-week voyage. He was asked by the British overseers in Quebec if he wanted to settle there. Despite the promise of a yoke of oxen, a year's provisions and a quarter section of land, the redoubtable Russell said, "No. I cannot agree to that. I have lived long enough under the English government and now that I am so near to free America, there I will go."

From Montreal, Russell and his family then sailed down the St. Lawrence River, through the Great Lakes and on to Milwaukee, which he called a "straggling village on Lake Michigan." The family first settled in Washington County, where no other people lived within ten miles of their farm. Descendants of Russell eventually spread on to Milwaukee and the world.

While there were Irish such as Russell early on in the community, most came directly from the Auld Sod as a result of the Famine.

However, these arrivals were not simply poverty-stricken peasants, but skilled farmers, craft workers, and mechanics who, along with their families, were considered a boon to Wisconsin's burgeoning young economy.

Agent Gregory placed advertisements in influential newspapers on the East Coast, such as the *Boston Pilot*, to tell arrivals that their chances of success in the New World were better in the far West. He also wrote numerous pamphlets tooting Wisconsin's perceived horn of plenty.

From these humble beginnings, we get a green-tinged Milwaukee, a city always ready for a parade on the High Holy Day of St. Patrick's, March 17. Such a tradition started early and continues today. In 1843, Fr. Martin Kundig, the second pastor of St. Peter's Church, organized a march led by the Wisconsin Catholic Total Abstinence Society. Most of the participants were Irish. Of course, this caused the local upper crust to assert that this would set sons of Erin on the path to "sober respectability." There is much more to being Irish these days in Milwaukee.

Arts and culture flourish with theater, music, film, dance, and poetry. It's natural .that Ireland's art capital of Galway is Milwaukee's Sister City. The pub scene at Paddy's on the East Side, Slim McGinn's in Walker's Point, Steny's on the South Side, O'Donohue's in suburban Elm Grove, Paul Quinn's place in the Third Ward, the Harp and Mo's downtown and all the other Irish and pretend-Irish watering holes help quench any "turrible turst." Irish-tinged parishes still mean prayer, parochial schools emphasize learning, universities bestow advanced degrees. The business, legal, and political Emerald Machine is understated but ever-present. It seems that just about everyone in town has a touch o' green, even if only philosophically.

One

HELLO MILWAUKEE
FINDING A NEW WORLD

Roger Gilligan probably had no idea that he was bulldozing history when he leveled a site in the 4300 block of North Richards Street for a new Wisconsin Telephone building. The year was 1953, as recalled by the late *Milwaukee Journal* reporter Bob Wells. Gilligan's heavy machinery had just taken out four panther mounds and one long mound built hundreds of years previously.

The earthen structures were constructed by an ancient Native people who preceded the Potawatomi, Ho-Chunk, and other American Indians who once called Milwaukee home in those long-ago pre-casino days. The Milwaukee mound-building occurred about the same time as Gilligan's Irish ancestors were dreaming up stories of all those heroes and High Kings. There was some talk that a few of the mounds were shamrock-shaped, indicating a definite pre-historic Irish link but that was never confirmed. Actually, as reporter Wells joked, more looked like bagels.

Yet well before Gilligan or even the Mound Builders, there were glaciers leveling what would be Milwaukee. When the ice finally melted, mastodons roamed the resulting bogs where Beer City would be built. There haven't been such large creatures in town since then, except for the elephants in Charles (Chappie) Fox's long-running Great Circus Parade. Fox, as everyone knows, is a descendant of the Foxes of Kilcoursey, County Offaly. Sandwiched between the mastodons and the circus elephants, exclusive of the Indians, were the French traders . . . and the British.

In 1779, the British warship *Felicity* sailed into the Milwaukee harbor from Fort Michilimackinac with an impressive load of weaponry carried by Scots and Irish soldiers from the 84th Regiment of Foot, Royal Highland Emigrants. The Brits hoped to stir up the Milwaukee locals, warning them "to be vigilant" in case any of the "Bostons," or colonial terrorists came nosing around.

All remained calm, however, allowing the settlement of the city to proceed; a process which continued full steam ahead. There is no record of when the first Gael strolled into the new town, which received its city charter in 1846. But whoever it was probably started work immediately. The biggest touch of Milwaukee's early Auld Sod was soon found in the Third Ward, once a swamp that was "filled in with Irish brawn and covered with Irish houses," according to old-timers. At one time, the Ward held 37 percent of the city's Irish. Among them was railroad magnate Thomas G. Shaugnessy, whose police detective father was a highly-placed Democrat. Young O'Shaugnessy went on to become president of the Canadian Pacific Railroad and was subsequently knighted by Queen Victoria. The rest, as they say, is merely history.

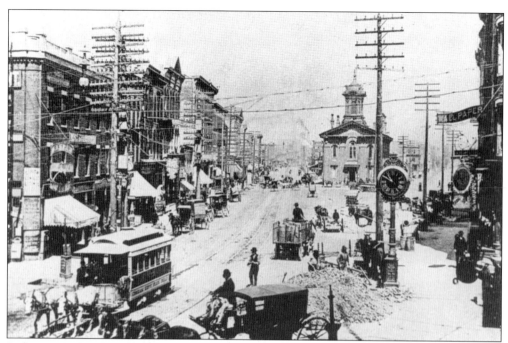

Irish émigrés found a bustling City Hall Square in downtown Milwaukee of the 1870s. The Old City Hall, at the corner of Water and Mason streets, is in the top center background beyond the clock. The building is on the same site as today's city hall, which dates to 1892. (Photo courtesy of the Milwaukee County Historical Society.)

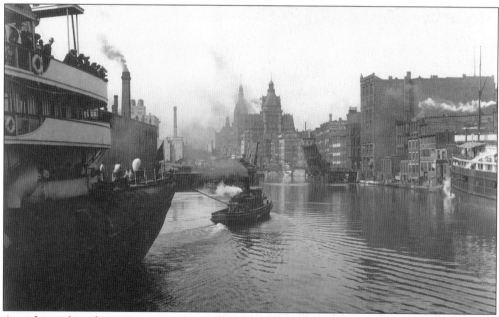

A tugboat clawed its way upriver towing a passenger vessel lined with passengers eager to glimpse the bustling city. In the far background is the Milwaukee City Hall. The port was one of the busiest on the Great Lakes, being the end point for tens of thousands of emigrants. (Photo courtesy of the Milwaukee Public Museum.)

Jeremiah Curtin was probably one of the most notable—if not the most educated and erudite—of Milwaukee's early Irish community. A graduate of Harvard, he became U.S. consul in St. Petersburg in 1864, was a highly-regarded linguist and a prolific author. His home in Greendale is now a popular tourist attraction and historic site. (Photo courtesy of the Milwaukee County Historical Society.)

John Anthony O'Connor was an early Irish settler in Milwaukee. Among his children was John O'Connor who in turn sired Ann O'Connor Neville, John Jr., Mary, Arthur, Julia, and Charles. (Photo courtesy of Mike Neville.)

11

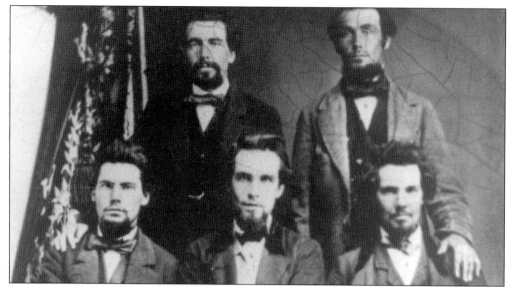

The five sons of Lawrence Mooney (1789–1871) of County Kildare, and Bridget Byrnes (1799–1885) of County Kilkenny, came to Canada with her mother, Ellen Browne Byrnes (1761–1863). The family also had two daughters: Ellen and Elizabeth. They then moved to the Milwaukee area in 1859, accompanied by their friends the Dockerys, Dineens, Reynolds, and Donahues. Three of the brothers served in the Civil War. Richard Mooney is seated on the far left, with Lawrence seated in the center. The others are unidentified. (Photo courtesy of Mike Mooney.)

Patriarch Patrick Russell of Templemore and his wife, Mary Martin, were surrounded by their family in this turn-of-the-last-century portrait. Clockwise from top center were Ed (with mustache), Ella, Jim, Maggie, Willie, Mae, Mike, John, and Albert. Patrick's voyage to Canada from Ireland took more than five weeks. His family then settled near Milwaukee and he eventually moved on to Iowa. But many of his Russell descendants remain in the Milwaukee community. (Photo courtesy of Jane Russell Holzhauer.)

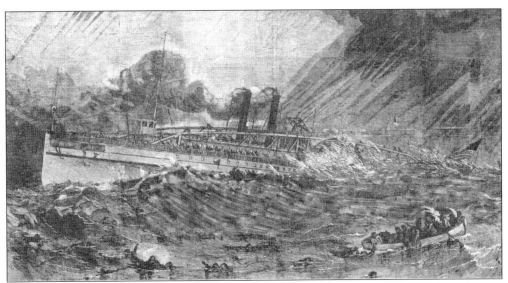

The sinking of the *Lady Elgin* on September 8, 1860, remains one of Lake Michigan's most tragic disasters. The side-wheeler captained by Jack Wilson was returning from Chicago with more than 400 passengers, mostly Irish residents of Milwaukee's Third Ward who had been on an excursion to hear a speech by Stephen Douglas. The Milwaukeeans included many city officials, the city band, and members of the police and fire departments. Several militia units, including the Independent Union Guards led by Captain Garrett Barry were also aboard. The Union Guards had organized the trip to raise money to replace weapons seized by Wisconsin Governor Alexander Randall who wanted them disbanded. Randall, an opponent of the federal fugitive slave law, was worried that the militia would be disloyal to the state because it supported the law. At 2:30 a.m., the *Lady Elgin* was rammed by the lumber schooner Augusta about ten miles from Winnetka, Illinois. It sank quickly in the wind-whipped waves. About 300 people died, although some casualty figures are quoted as being higher. Bodies washed ashore for months afterwards. Many of the dead are interned in Calvary Cemetery. (Sketch from *History of Milwaukee*, 1922, courtesy of the Sheldon Solochek collection.)

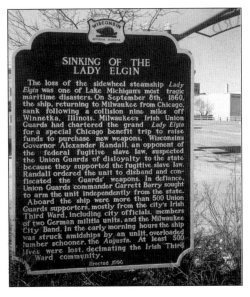

A marker describing the sinking of the Lady Elgin stands at the north end of the Water Street bridge over the Milwaukee River in Milwaukee's Historic Old Third Ward. (Photo by author, courtesy of *The Irish American Post*.)

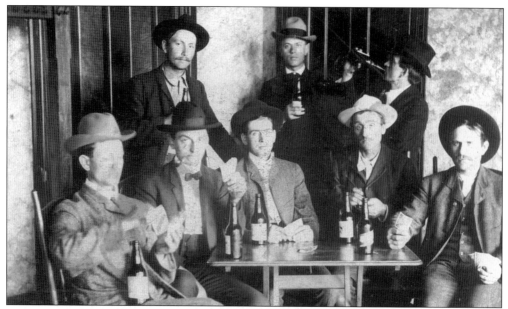

Several of the boyos took time out from work to quaff a brew in one of Milwaukee's many watering holes. Among the city's tavern keepers was John McCarthy, who became proprietor of the Union House after a stint as a lakes sailor and veteran of the Civil War. Ireland-born John Curran ran a bar and billiard parlor on Lincoln Avenue. Richard Casey, who launched the local chapter of the Ancient Order of Hibernians in the late 1880s, ran a saloon at 67 North Third Street Tom Doorley's father, a member of the ill-fated Union Guards, died in the Lady Elgin shipwreck. Young Doorley operated a bar at 196 Erie Street (Photo courtesy of the Milwaukee County Historical Society.)

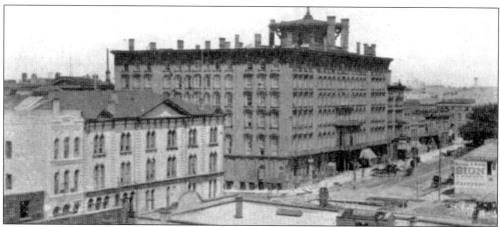

The Newhall House was one of Milwaukee's finest hotels during the city's early years. Built in 1857, the six-story brick building was located at the northwest corner of Broadway and Michigan. The first landlords were partners M. Kean and A.M. Rice, who operated it until 1860. The Newhall burned to the ground on January 10, 1883, killing 75 staff and residents. Among the dead were a number of Irish maids and kitchen staff, as well as immigration agent David Power, who was instrumental in bringing numerous immigrants to Milwaukee from Ireland. However, Gen. and Mrs. Tom Thumb of P.T. Barnum fame were rescued from the blaze. (Photo courtesy of *History of Milwaukee*, 1922, courtesy of the Sheldon Solocheck collection.)

John Murphy and Catherine Condon were ready for a long, happy life together in this marriage photo from February 14, 1881. The couple lived in a house now on the site of Gesu Church on today's Marquette University campus. (Photo courtesy of Celia Farran.)

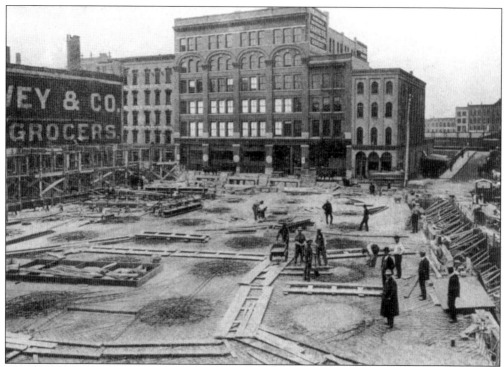

The Third Ward, home of numerous early Irish families, was heavily damaged in a "mountain of fire" on October 28, 1892. Four persons died in the blaze that destroyed 440 buildings and displaced more than 1,900 Milwaukeeans. In 1906, Irish craftsmen were among the laborers working on the foundation of the Marshall Building, one of the many structures built on

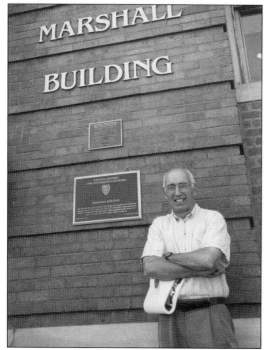

the ruins of the burned-out ward. The resulting building on the corner of Water and Buffalo streets is the world's oldest example of flat-slab floors, a revolutionary method of pouring concrete. The building is now a National Historic Landmark. The scene looks west along Buffalo toward the Milwaukee River. The large building in the center background now houses the Milwaukee Ale House, brewer of a fine stout. (Photo courtesy of the Marshall Building.)

Author Mike Mooney is also manager of the historic Marshall Building in Milwaukee's Third Ward. A talented storyteller, Mooney has had three books of fiction published, as well as numerous magazine short stories. He had a doctorate in medieval and Renaissance English literature from Edinburgh University. (Photo by author, courtesy of *The Irish American Post*.)

Milwaukee Dr. George William (Bill) Fox is shown here in 1908 as an infant on horseback with his father, Dr. Philip Fox (1840–1932). In 1893, the elder Fox visited the ancestral Fox home in County Meath and commented on the landlord-tenant situation he found there. In an interview upon his return, Fox remarked that "the (Charles) Parnell side think they are gaining, and the other side admit it, and it is hoped that continued agitation will make this land of plenty something else than the abode of famine to her toiling children." Young Bill was killed in World War II. (Photo courtesy of William F. Fox.)

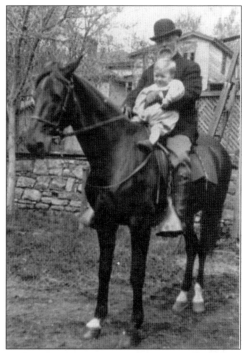

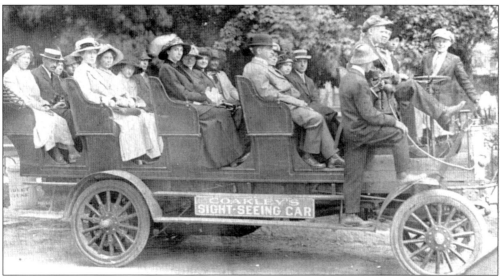

Coakley Brothers supplied transportation, delivery, and storage services for messenger companies such as Western Union. The firm also picked up commodities arriving in Milwaukee by steamship or railcar. Deliveries were made to merchants and families using horse and coach. By 1906, horse and coach were replaced by trucks. On weekends when the docks and depots were quiet, the brothers gave sightseeing tours. They removed the sides of their delivery truck, fastened rows of pews atop the truck bed and furnished them like touring buses. The tours went along the upscale Lake Shore Drive, as well as Wisconsin and Prospect avenues. The Coakleys' passengers could gaze at the stately homes of noted Milwaukee families like the Pabsts, the Harnischfegers and the Mitchells. In 1915, 14-year-old Charlie Coakley (in cap at front of truck) gave the tour spiel. (Photo courtesy of the Coakley family.)

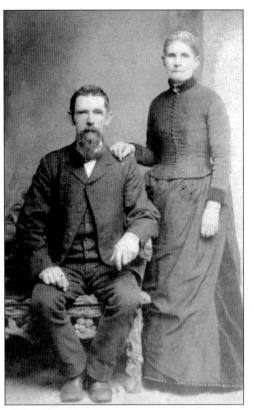

John Burke and his wife, Mary Nolan Burke, came to the United States from County Mayo during the 1840s. They landed in Boston but eventually settled on a farm near Watertown. Of their children, two of the three youngest—William and Frank—settled in Milwaukee. The third, Joseph, became a priest and was a dean at the University of Notre Dame. He eventually became president of St. Edward's College in Austin, Tex. (Photo courtesy of Grace Burke Boemer.)

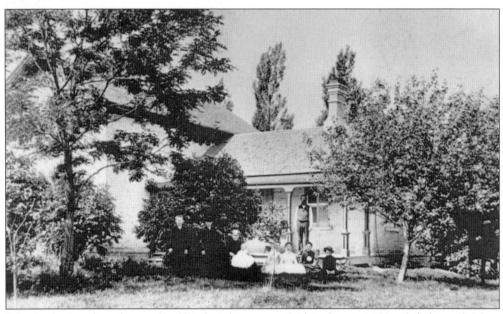

John Burke stood on the porch of his farm home near Milwaukee in 1878, while his wife Mary and several of their children gathered around in front of the house. She held baby Frank, with their sons William and Joseph seated at the far left. The other children are unidentified. (Photo courtesy of June Burke Hanson.)

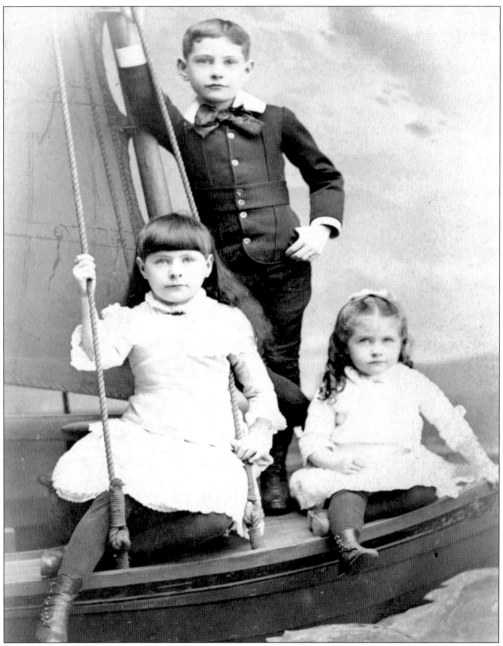

The three children of John and Mary Louise Reilly were dressed to perfection for their portrait. Harry stood at the mast, while Frances (Faun) and Grace were ready for some pretend sailing action. The elder Reillys came to the United States from County Cork in the 1840s. They settled in Albany, N.Y., until coming to Milwaukee in the 1880s to work as tailors. Faun and Grace would become Milwaukee public school teachers, while Harry became a chemical engineer and moved to Nebraska. Faun married Frank Burke (the baby seen on the preceding page). There are subsequently dozens of descendants of both the Burke and Reilly families living in the Greater Milwaukee area, including Boemers, Gudes, and Hansens. (Photo courtesy of Grace Burke Boemer.)

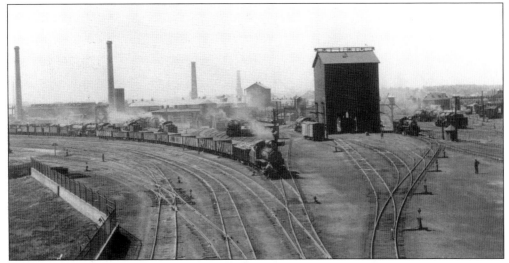

Newly-arrived Irish and their descendants found well-paying jobs working in the rail shops and in other positions with the Milwaukee Road. Patrick Sullivan was foreman of the brass foundry. Irish-émigré L.G. Clarke was storekeeper at the North Milwaukee shops, coming Stateside in 1840. Dublin-born Thomas Carroll and Waterford native Thomas O'Donnel were engineers. The list goes on for the system was launched as the Milwaukee & Waukesha Railroad by Byron Kilbourn in 1847. It morphed into the Milwaukee & Mississippi once it stretched westward across the state to Prairie du Chien in 1850. In 1874, after several other name changes, the firm became the Chicago, Milwaukee, & St. Paul. Eventually the railroad became the largest in the Midwest. (Photo courtesy of the Milwaukee County Historical Society.)

The sprawling Milwaukee road rail yards in the Menomonee Valley were a short walk from workers' homes in Merrill Park, the Irish neighborhood that spread across the bluffs to the north. The Irish had trickled into the area after the disastrous Third Ward Fire in 1892. (Photo courtesy of the Milwaukee County Historical Society.)

Two

BUSINESS
MORE THAN COCKLES AND
MERE MUSSELS

The Irish in Milwaukee have been butchers, bakers, bankers, and banjo players. Their enthusiasm to carve out a niche for themselves in the New World was readily obvious the minute they walked down the gangplank and looked for work. It was not long before they were owning their own firms and making a mark in the corporate hierarchy all around Beer City.

While the names of the early business leaders may not be so familiar today, their heritage lives on. Business was so good in town that a Board of Trade was founded in 1854. By the end of the Civil War, Irish entrepreneurs had found their way into the higher reaches of the Milwaukee Chamber of Commerce; among them were George D. Russell, John Cudahy, and William Cudahy, all of whom served in a variety of positions.

Demonstrating early Milwaukee's agricultural commodities background in the 1850s, '60s and '70s, Isaac Black—the city flour inspector—was born in the north of Ireland in 1824. He emigrated to Canada and learned the baker's trade there, coming to Milwaukee in 1864. His wife, Mary Bell, was also a native of Northern Ireland. They had three children, including son John T. who became assistant fire chief for the city. Around the same time the Irish-born A. Salisbury was named Milwaukee's assistant grain inspector and became a school commissioner. The father of grain merchant John Foley, John Sr., was one of Milwaukee's first settlers. The fathers of both Eugene Carey and Hector Riggs, wholesale feed and grain dealers, were also born in Ireland.

The Gaels filtered into many other businesses. Irish-born Maurice Kennealy did double duty as a grocer and saloon keeper, coming to Milwaukee in 1849, starting his own business in 1879. Another major grocer in the 1870s was butcher James Kerwin, who was born in Ireland and came Stateside in 1847, eventually coming to Milwaukee in 1862. John McGrath, who operated a food store at 302 North Van Buren Street, was another Irish-born Milwaukeean.

Even Milwaukee's Dublin-born mayor Hans Crocker had a hand in business, being a partner in the Milwaukee Manufacturing Company, a firm in the 1870s that made augers.

It can be duly noted that today, Milwaukee's Irish business community is still making a difference. Sometimes the contributions have to do with science. In the 1920s, Daniel S.W. Kelly, an Allen-Bradley County engineer, helped develop a prototype battery that put the company on the industrial map.

How about today's business. Here are some presidents: P. Michael Mahoney, Park Bank; Robert O'Toole, A.O. Smith.; and John Shiely, Briggs & Stratton. The Metro Milwaukee Association of Commerce has been headed since 1992 by Tim Sheehy.

As far as women are concerned, top the list with Catherine B. Cleary, daughter of the late Michael Cleary, who was president of Northwestern Mutual Life Insurance. She rose to be chairman of the First Wisconsin Trust Company from 1976–1978 and has served on the boards of numerous other firms, including AT&T, Kraft Foods, and General Motors. Cleary remains active in supporting opportunities for women in business.

The names go on and on.

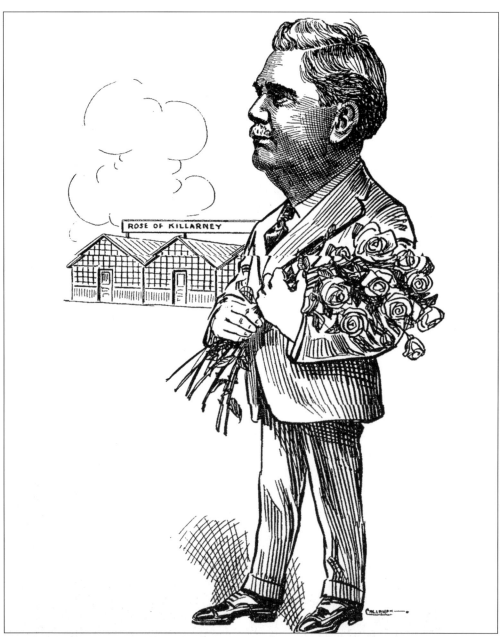

Patrick Cudahy was born on St. Patrick's Day in 1849 in Callan, County Kilkenny. He and his family emigrated to Milwaukee when he was three months old, and lived on 8th and Clybourn streets. Cudahy followed his older brothers into the meat business and eventually became superintendent of the Plankinton & Armour packing firm, acquiring part-interest in the company after a few years. In 1888, he and his brother John formed the Cudahy Brothers Company, with a plant in the Menominee Valley. The firm became known as the internationally respected Patrick Cudahy, Inc. Cudahy also founded the city of Cudahy, on Milwaukee's south side, in 1893. This cartoon of Patrick was done in the early 1900s by an unknown member of the Milwaukee Newspaper Artists' Club. Cudahy was an active member of the Friends of Irish Freedom and the Ancient Order of Hibernians. (Sketch courtesy of the Feerick Funeral Home.)

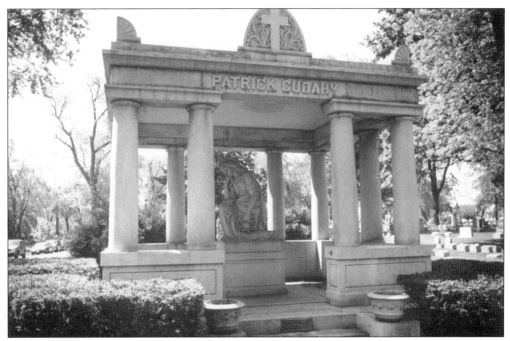

The Patrick Cudahy mausoleum in Calvary Cemetery is one of the more imposing burial plots in the community. The cemetery is the final resting place of many other notable . . . and ordinary . . . Irish and Irish Americans. Cudahy died on July 25, 1919, with his funeral at St. John the Evangelist Cathedral and a memorial service at his plant attended by more than 1,000 persons. (Photo by author, courtesy of *The Irish American Post*.)

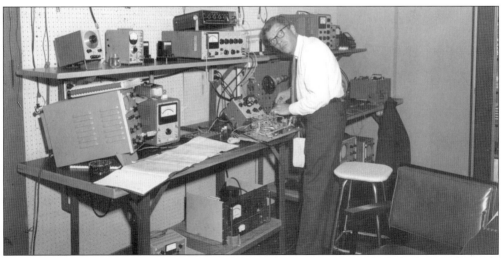

Michael Cudahy, grandson of Patrick Cudahy, is bent over his work desk during the early years with his Marquette Electronics. Cudahy's father John was United States' ambassador to Ireland from 1937 to 1939. While living in Ireland, young Cudahy became fascinated with wireless sets and once fell through a skylight roof in their Dublin home while attempting to rig an antenna. He was uninjured and, as an adult, went on to build up his electronics company, which was eventually sold to General Electric. Cudahy is one of Milwaukee's most generous philanthropists. (Photo courtesy of Michael Cudahy.)

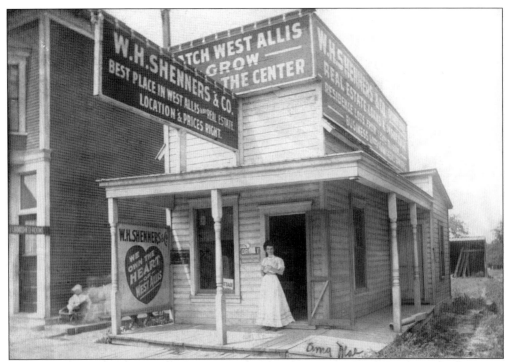

The W.H. Shenners real estate company handled properties throughout the booming Greater Milwaukee area, although it concentrated on the West Allis area and Milwaukee's lower west side. Anna Mae Shenners stands on the porch of the building that occupied a quarter-block on the west side of South Seventieth Street, north of Greenfield Avenue. She and her four sisters married five Russell brothers. (Photo courtesy of Jane Russell Holzhauer.)

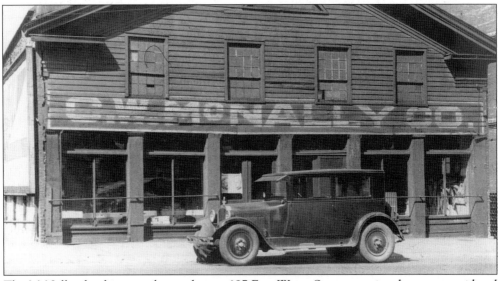

The McNally plumbing supply warehouse, 197 East Water Street, was in what was considered one of Milwaukee's oldest buildings. A customer could literally purchase anything and everything from McNally, including the kitchen sink . . . or two . . . or even three. (Photo courtesy of the Milwaukee County Historical Society.)

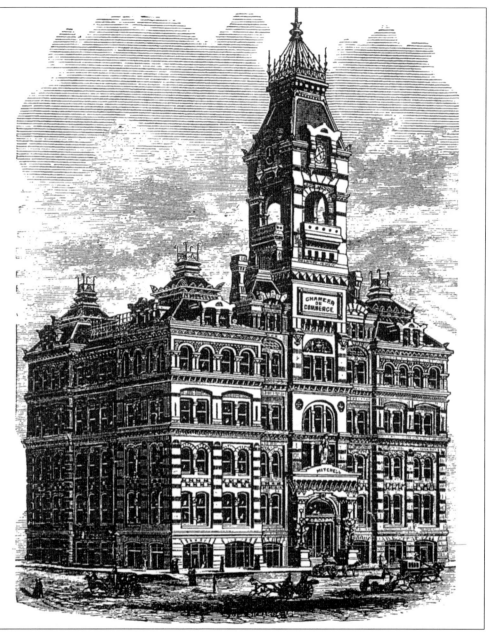

The Chamber of Commerce building of the 1880s was made of gray Ohio sandstone in the Italianate style, located on the corner of Michigan and Broadway. Above the entrance were statues of the bull and bear, of stock fame and sometimes fortune. One 10 x 24 foot painting inside was executed by John S. Conway, depicting assorted maidens and miners as representatives of commerce. At its inauguration on November 18,1880, Thomas A. Balding made the first purchase; 1,000 bushels of wheat from dealer Alexander C. Ray. Within ten minutes, 200,000 bushels had been sold. Bach's orchestra then played, followed by a concert of the Chamber of Commerce Choir under the direction of Will Graham. A dinner followed at the Newhall House, attended by dignitaries from around the country. (Sketch from *History of Milwaukee*, 1888, courtesy of the Sheldon Solochek collection.)

Businessman James Fletcher Fox was president of Fox's Incorporated, a florist/confectionery firm founded in 1882 by his father James M. Fox. His grandfather, Presbyterian minister Matthew A. Fox, was born in Ireland and emigrated to Wisconsin as a young man to settle near Madison. A graduate of the old Milwaukee Academy in 1899, Fox worked in many positions with his father's firm. When James M. died in 1916, his son took over the business as president. Active in the Milwaukee Association of Commerce, Sullivan was also a member of Holy Rosary parish and the Milwaukee, Athletic, and Town clubs. (Photo from *History of Milwaukee*, 1922, from the Sheldon Solochek collection.)

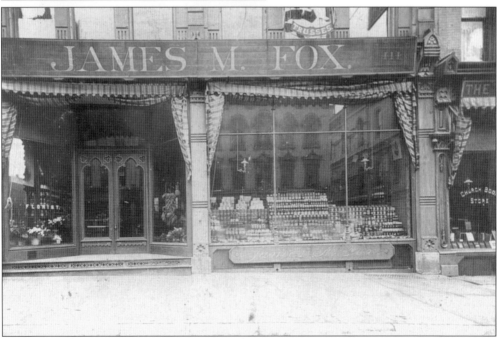

The James M. Fox florist and confectionery shop in Milwaukee also did a booming wholesale business in tea and coffee. The building was located at 414-416 Milwaukee Street. This photo dates from 1890. (Photo courtesy of the Milwaukee County Historical Society.)

Gordon Russell stands outside his real estate office in Milwaukee sometime in the mid-1940s. An unidentified youngster joined him. The Russell family was instrumental in developing large tracts of Greater Milwaukee for housing an-d business. His son, Dennis, became a Wauwatosa-based appraiser and developer and is active in a business consulting group with the Irish Cultural and Heritage Center. (Photo courtesy of Jane Russell Holzhauer.)

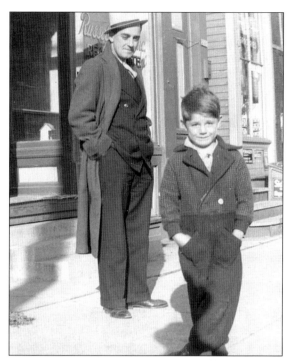

In 1932, Joe Russell was ready for business at his new Realty office three doors west of South Twentieth Street on the North Side of West National Avenue. He was part of the Russell real estate dynasty that bought and sold properties throughout the region. (Photo courtesy of Jane Russell Holzhauer.)

Bill Dooley and Mollie Shenners look up from their desks in a Milwaukee office of the early 1900s, as highly qualified young Irish American workers began taking their places in the white-collar business world. (Photo courtesy of Jane Russell Holzhauer.)

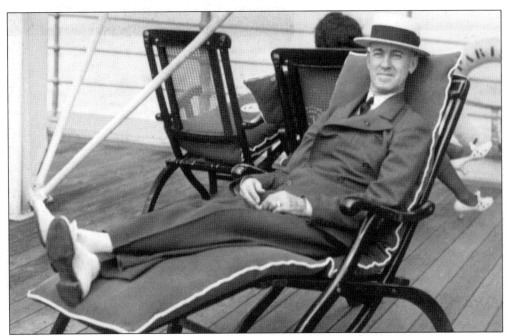

When Joe Lynch opened a men's clothing store in Milwaukee in 1925, the entire city knew it. The dapper Irishman ran a full page teaser campaign in *The Milwaukee Journal* for four successive days prior to the store's grand opening. The progressive headlines read: "Who's Joe Lynch?", "What's Joe Lynch?", "Where's Joe Lynch?", and "Here's Joe Lynch!!!" Known for introducing the Hart Schaffner & Marx label to Milwaukee, Lynch maintained high fashion men's clothing stores for 38 years at various locations on Wisconsin Avenue. This self-made businessman was born in Mineral Point, Wisconsin, the son of an Irish immigrant from County Monaghan. Here he is taking a well-deserved vacation trip to Paris in 1938. (Photo courtesy of Sue Riordan.)

A cigar-chomping Bill Coakley took a break from running his van line in 1920 to bounce his adopted daughter Lucille on his knee. Since there were no car rentals at that time, he regularly drove his auto on a train flatcar and headed off to New York, Texas, Arkansas, Los Angeles, or San Francisco. The vehicle could then be unloaded and he'd vacation in style. He and his brothers Charlie and George founded the Lightning Messenger and Express Company in 1888. They changed the name in 1889 to The Coakley Brothers Company, with offices on West Wisconsin Avenue near North Plankinton. Today, the Riverside Theatre is on the site. (Photo courtesy of the Coakley family.)

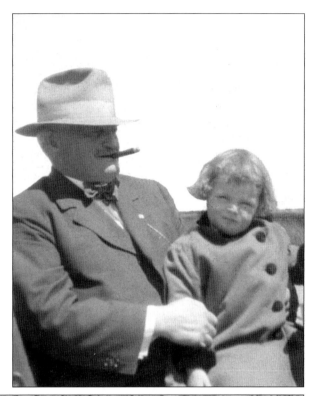

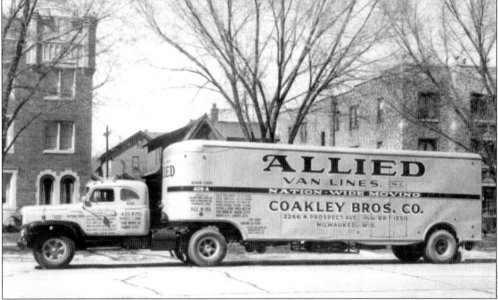

Coakley Brothers affiliated with Allied Van Lines in 1933, routing deliveries around the country. The firm is still going strong, under the leadership of George Coakley's grandson Neil and Neil's daughter Peggy. Keeping up with the times, the firm started a records retention unit to ship records and paperwork. Neil invented the "porta-rack" in 1978 to better balance the contents of their trucks. In 1998, Peggy launched the firm's furniture installation division. (Photo courtesy of the Coakley family.)

William Feerick, founder of the Feerick Funeral Home, was born in County Mayo and came to the United States as an infant. In 1896 at age 21, young William began an undertaking and livery firm at 2330 Cherry Street. The facility was complete with its own embalming facilities. The second floor held living quarters. By the time he was 24, Feerick owned his own building, plus stables, hearses, and carriages. His roan horses were noted for their ornate bells and large plumes. Feerick's 18-year-old son Ralph had joined his father in business in 1914. He helped his father open a larger business at North Avenue and Forty-sixth Street. The elder Feerick died in 1937 at the age of 72. (Photo courtesy of Feerick Funeral Home.)

Feerick Funeral Home's ornate carriages were eventually replaced by autos as seen in this photo. Ralph Feerick developed a system of airtight vaults where the deceased could be laid until relatives and friends could travel to Milwaukee for the funerals. The company name became Wm. C. Feerick and Son Funeral Home. In 1933, the firm expanded to another location on East Capitol Drive in Shorewood. (Photo courtesy of Feerick Funeral Home.)

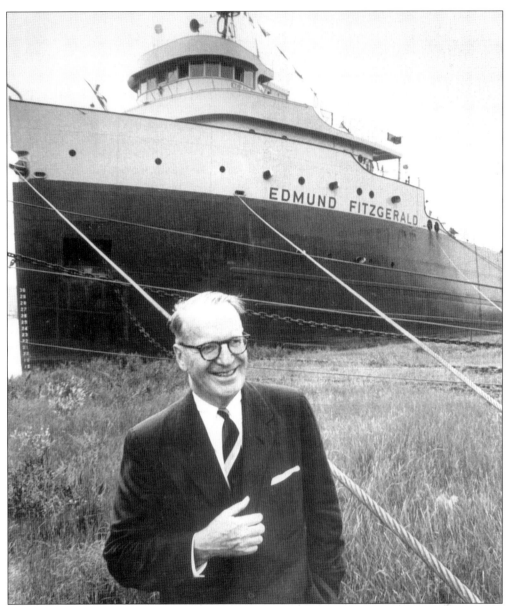

Edmund Fitzgerald, born in 1895, was descended from a long line of powerful Irish nobility dating back to medieval days. His paternal great-grandparents were natives of Oola parish, CountyLimerick. In 1835, the first of his Fitzgerald clan emigrated Stateside and a number of descendants became noted ship captains, boat builders, and owners of Great Lakes vessels. Long a community leader, Edmund Fitzgerald became president of Northwestern Mutual Life Insurance in 1947, succeeding Michael Cleary. Fitzgerald then became the company's board chairman in 1958. In the same year, his name was applied to the largest ore carrier ever seen on the lakes. The *Edmund Fitzgerald* was 729 feet long and had a capacity of 25,891 tons, becoming the most glamorous freighter ever built. However, it sank in a fierce Lake Superior storm on November 10, 1975. Gordon Lightfoot's song "The Wreck of the *Edmund Fitzgerald*," remains a haunting, unforgettable tune. Fitzgerald himself died in Milwaukee on January 8, 1996. (Photo courtesy of Northwest Mutual Life Insurance Company.)

Maureen Murphy has operated Tralee Irish Imports since 1983. Born in Tralee, County Kerry, she was adopted in Ireland and came Stateside at age 15 months. Her dad Peter is an Irish native and her mom, Rose, has been her long-time business partner. Brother Dennis is an attorney who plays guitar and mandolin with the folk group Blarney. (Photo courtesy of *The Irish American Post*.)

Foodstuffs from Ireland and Britain line the shelves at Jerry O'Brien's European Meat Market and Fran's Italian Deli near the Wisconsin State Fair. O'Brien's family migrated from the Limerick area to Yorkshire after World War II. O'Brien then came Stateside in 1987 and worked at the old Glorioso's store in Wauwatosa. He bought that out in 1991, turning an Italian touch into Irish/Italian because, after all, his wife Fran Naczek-Maglio O'Brien makes some of the best soda bread outside the Auld Sod. (Photo by the author, courtesy of *The Irish American Post*.)

Three

THE CHURCH
OUR FATHER AND HAIL MARY

As with any Irish immigrant community in America, the church, parish, and school were all-important components of life in unfamiliar new surroundings. Any kind of Irish connection helped ease the transition. One of the first priests in Milwaukee was Father Patrick O'Kelley, born in County Kilkenny. He came from Detroit in 1837 and built St. Peter's Church, Milwaukee's first Catholic church. That structure is now part of the state historical society's Old World Wisconsin. Fathers Thomas Morrissey and Peter McLaughlin arrived as missionaries in 1838, with McLaughlin becoming first fulltime pastor at St. Peter's. The Sisters of Charity of Emmitsburg, Maryland, went to Milwaukee and started St. Joseph's school in the basement of St. Peter's Church shortly after they arrived in 1846.

The growth of the city was marked by the establishment of its parishes, with St. Mary's Church on Broadway being consecrated in 1847, and the cornerstone of St. John the Evangelist Cathedral being laid in the same year. Next came St. Gall's on the West Side and Holy Trinity on the South Side. Construction on St. Francis Seminary began in 1855.

St. Rose's Orphan Society, founded in 1848, also utilized the basement of St. Peter's. The need for such a facility was obvious when pastor McLaughlin brought 4-year-old Katie Colfer to be cared for after her parents, newly arrived in Milwaukee from County Wexford, had died of typhus. Katie eventually joined the Daughters of Charity, becoming known as Sister Martha.

Religious communities were instrumental in helping early Milwaukee develop a strong social service and school system. St. Rose's Orphanage was opened by Bishop John Martin Henni in 1849. First on Van Buren Street, the orphanage was moved in 1853 to a brick building on Jackson, north of the cathedral. In 1860, the complex was shifted to a site near St. Mary's Hospital.

The clergy and religious orders worked incessantly on behalf of the souls under their care, both spiritually and physically. Father Patrick J. Donahue, born in County Dublin in 1810, was St. Mary's first resident chaplain, after retiring as pastor of St. Peter's Church in 1880. He had been at St. Peter's in 1854 during an outbreak of cholera, and also helped with funeral services in 1860 following the sinking of the *Lady Elgin*.

Father James J. Koegh, another pastor of St. John's, was born in 1847 in County Wexford, coming to the United States in 1856. He attended St. Francis Seminary and was ordained in 1871. Reverend Edward Patrick Lorigan was born in 1840 near the River Shannon in County Limerick. He served at various parishes in the East and South before returning to Milwaukee and St. John's in 1878.

The laity were also very active in Milwaukee. The Young Men's Sodality was organized in 1876, with some of its first officers including Thomas Neville, Michael Foran, Thomas Finnegan, and P.J. Maher. Kate Donovan was one of the first presidents of the Young Ladies' Society. St. Ann's Society, which assisted priests with their vestments and cared for church sanctuaries, had more than 150 members in the 1870s.

This link between church and service ensured that the roots in Milwaukee, planted by Irish émigrés and nourished by their descendants, would provide a strong base for the spiritual growth of ensuing generations.

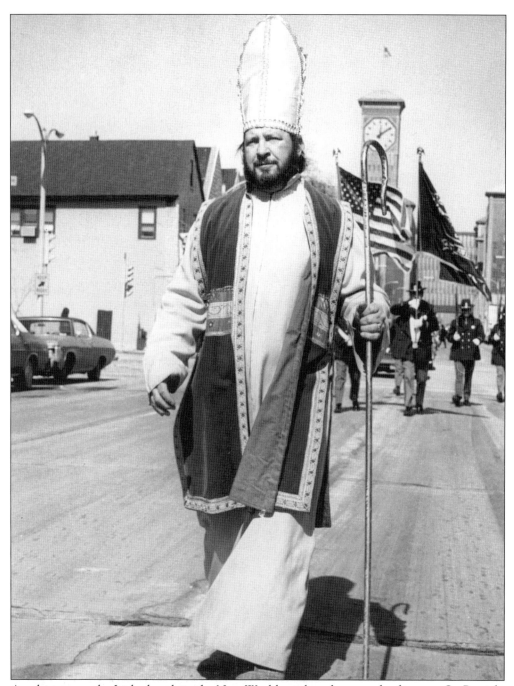

Any history on the Irish church in the New World needs a photograph of its own St. Patrick. During many of the High Holy Days in March throughout the early 1970s, Pat McMahon led the parade sponsored by the Shamrock Club of Wisconsin. No snakes were ever found along the route when Pat headed the procession. (Photo by Robert J. Higgins, courtesy of the Shamrock Club of Wisconsin.)

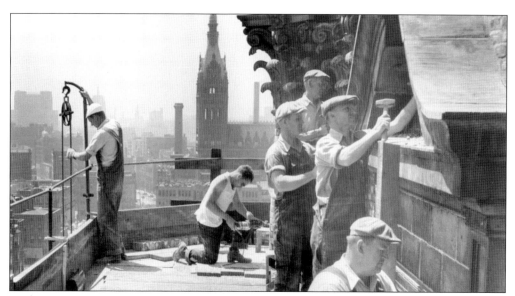

With a panorama of the city behind them, most notably with City Hall in the background, workmen repaired the steeple on St. John the Evangelist Cathedral sometime between 1936 and 1943. St. John's has been the seat of the Catholic Archdiocese of Milwaukee for more than 150 years and religious home to many of the city's early Irish Catholics. The cathedral's cornerstone was laid on December 5, 1847, and its appearance has not changed much except for the tower constructed in 1893. (Photo courtesy of the Archdiocese of Milwaukee archives.)

Firefighters attempt to save the cathedral during a fire on January 29, 1935, that heavily damaged the structure. Many historic paintings and memorials were destroyed in the blaze. During the rebuilding, the east end of the church was enlarged. About seventy years later, St. John's was renovated and then rededicated on February 9, 2002. (Photo courtesy of the Archdiocese of Milwaukee archives.)

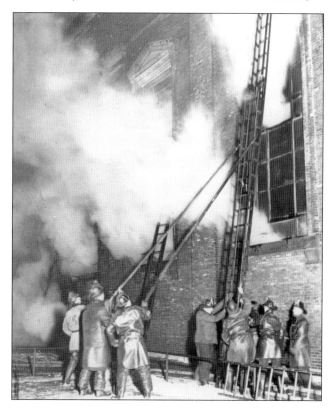

Young Father Moses Elias Kiley (with the Roman collar, back row) studied for the priesthood in Rome. It is presumed that this shot depicts him on a ship either coming or going to Italy. Born November 13, 1876, in Margaree, Nova Scotia, Kiley went on to become the sixth archbishop of Milwaukee. (Photo courtesy of the Archdiocese of Milwaukee archives.)

Milwaukee Archbishop Moses Kiley entertained some youngsters during his long stay in the city. He was ordained a priest on June 10, 1911, in Rome, and was appointed bishop of Trenton, New Jersey on February 10, 1934. Kiley was then appointed archbishop of Milwaukee on January 1, 1940. He died on April 15, 1953. (Photo courtesy of the Archdiocese of Milwaukee archives.)

Milwaukee Archbishop Samuel Alphonsus Stritch was born in Nashville, Tennessee, on August 17, 1887. He entered college at age 16 and attended the North American College in Rome, being ordained in 1910 in Rome. Before entering the episcopate, he served in Memphis and Nashville. He was made Bishop of Toledo, Ohio, at the age of 34. Stritch was then sent to Milwaukee to be installed as archbishop in 1930. Among Stritch's accomplishments was the launching of the archdiocese's Catholic Youth Organization program. He was again transferred in 1939, this time to the Archdiocese of Chicago and was made a cardinal on February 18, 1946. Stritch died on May 27, 1958, in Rome. Stritch was the first archbishop of Milwaukee of Irish ancestry. His father was born in Ballyheigue, County Kerry. (Photo courtesy of the Archdiocese of Milwaukee archives.)

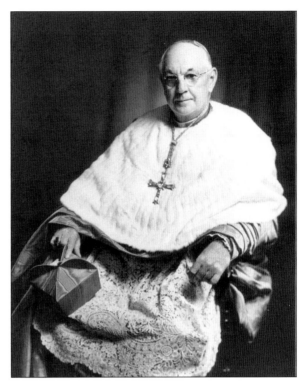

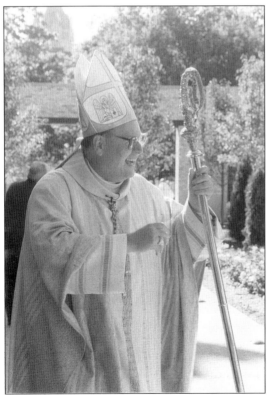

Archbishop Timothy Dolan made his grand entrance into Milwaukee at the 2002 Milwaukee Irish Fest mass in front of 14,000 people, four days before officially taking over his archbishop's duties. The St. Louis-area native was ordained in 1976. From 1994 to 2001, then-Bishop Dolan was rector of the Pontifical North American College in Rome where he served until June, 2001. He has visited Ireland about 10 times. (Photo by John Alley, courtesy of *The Irish American Post*.)

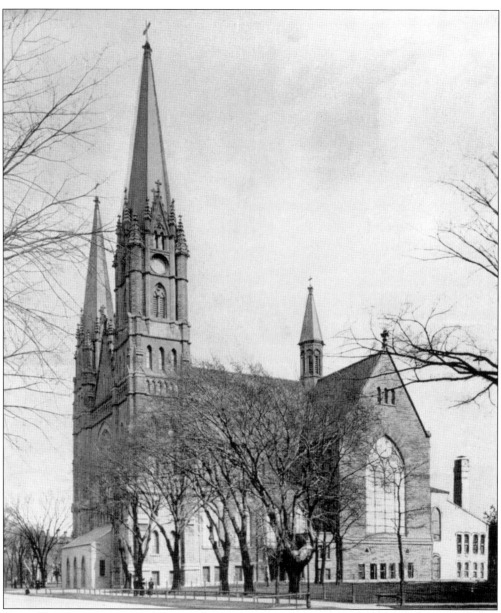

Gesu Church is the spiritual heart of the Marquette University campus, west of downtown Milwaukee. Administered by the Jesuits, it serves more than 2,500 worshippers during the weekend services. Gesu began in 1849 as a union between St. Gall's Parish and Holy Name parishes. In 1893, the parish was renamed Gesu, named for the church in Rome where St. Ignatius, founder of the Jesuit order, is buried. The current church was dedicated on December 17, 1894. (Photo courtesy of Marquette University archives.)

The Reverend Thomas S. Fitzgerald is typical of the Jesuits serving as pastor at Gesu Catholic Church, taking over its administration in 1899. He was a teacher at Marquette and was the college's president when the first class graduated. Prior to coming to Marquette, he taught in St. Louis and Cincinnati. (Photo courtesy of Marquette University archives.)

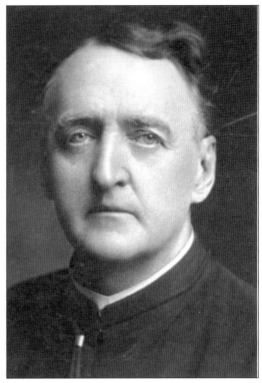

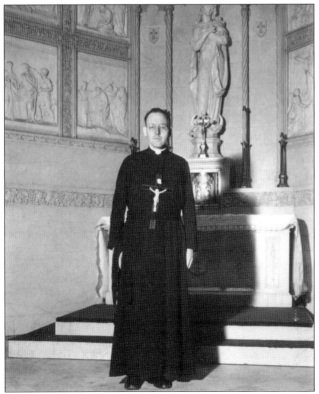

Father John J. Halloran was assistant pastor of Gesu Church from 1967 to 1970 and pastor to 1975, helping many Marquette students deal with the complexities of the Vietnam War and the meaning of peace in the modern world. An excellent preacher, he could draw from his experiences as an Army chaplain in World War II and Korea. Halloran died in 1985 and is buried in Milwaukee's Calvary Cemetery. (Photo courtesy of Marquette University archives.)

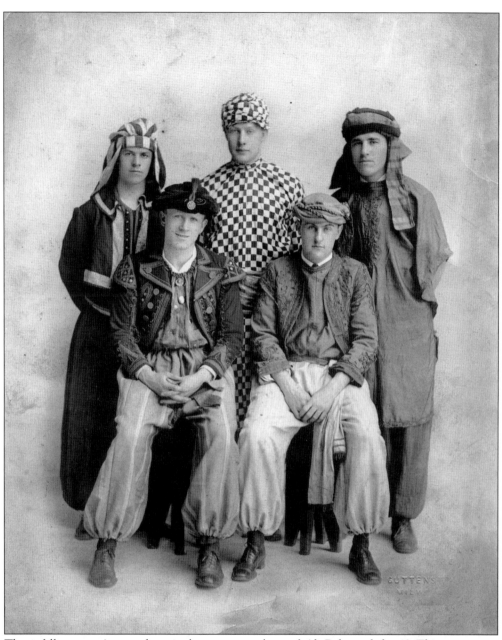

These fellows aren't new deacons but cast members of *Ali Baba and the 40 Thieves*, a stage production presented at Marquette University in 1922. Starring were (left to right, top row) Thomas Stemper, John Cavanaugh, and Robert Raison, and (seated, left to right) Joe (Red) Dunn, and Richard Quinn. Dunn went on to be longtime football coach at the university. A Catholic higher education meant getting involved in such fun activities, as well as studying hard. (Photo courtesy of the Marquette University archives.)

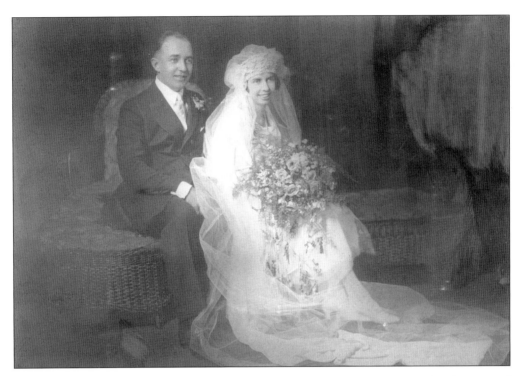

A plentiful supply of young Irish Catholic couples being married in Milwaukee's churches ensured that the parochial schools would remain busy throughout the 1920s and 1930s. In the top photo, Bill and Victoria Dooley posed for their wedding photo and in the bottom shot, Lorraine Russell was the vibrant bride of Danny McIlhon. (Photos courtesy of Jane Russell Holzhauer.)

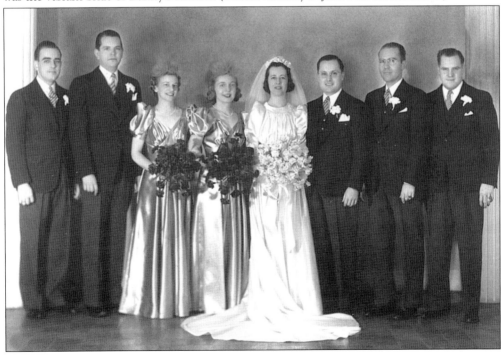

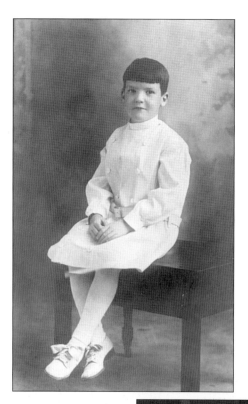

A well-dressed Matthew J. Sullivan was ready for a successful First Holy Communion at St. John the Evangelist Cathedral. Sullivan was born in his parents' home on Detroit Street in 1904 and died in 1993. He retired in the late 1960s after a long career as an aeronautical engineer at Cutler-Hammer Corporation where he worked on the Mercury and Apollo space programs. (Photo courtesy of Bill Sullivan.)

Wearing her new dress and veil, Monica O'Meara's was ready for her First Communion in 1965. Lending support was the rest of the O'Meara clan, with older brother Dave partially hiding a bashful sister Anne. On Monica's right was Mary Joy with Jack standing in front. (Photo courtesy of Dave O'Meara.)

Holiday pageants were always integral to parish life throughout the Milwaukee archdiocese. This children's Christmas program at Immaculate Conception meant that the Joseph, Mary, and angel characters needed to be on their best theatrical (and spiritual) behavior. (Photo courtesy of Immaculate Conception Parish and the Milwaukee Archdiocese archives.)

Catherine Cudahy was born in Callan, Ireland, in 1846 and then spent most of her life looking after her parents, Elizabeth and Patrick Cudahy. When her mother died in 1871, followed by her father 10 years afterwards, Catherine became a sister. Taking the name as Sister Stanislaus, she lived at the Convent of Good Shepherd in Milwaukee. She died at age 46 in 1892. (Photo courtesy of Michael Cudahy.)

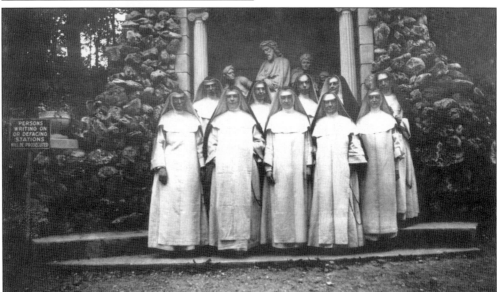

The good sisters at St. Matthew's Grade School in the 'teens and 'twenties ran a tight ship, encouraging learning being uppermost on their collective minds. St. Matthew's Church was dedicated in 1892, with the parish so poor that it did not have pews at first. Subsequently, police officer John McCarthy would borrow wooden picnic benches from Mitchell Park to use during mass. The first real pews were hand-me-downs from St. John the Evangelist Cathedral. David Geraghty donated the first altar railing. Among the early parishioners were the Kellys, Flynns, Rileys, Mehegans, O'Keefes and Dohertys. (Photo courtesy of Jane Russell Holzhauer.)

Chicago native Sister Juliana Kelly joined the Daughters of Charity beginning her religious service in 1939 at Charity Hospital in New Orleans. She then was an administrator at St. Vincent's in St. Louis and was transferred to direct operations at St. Mary's Hospital in Milwaukee. Sister Juliana remained at the facility from 1966 to 1978. Under her direction, the hospital's first coronary unit opened in 1968. The first surgical intensive care unit was set up the next year. Dr. Tom O'Connor was on the team when the first coronary bypass was performed at the hospital in 1971. (Photo courtesy of the Daughters of Charity archives, Evansville, Indiana.)

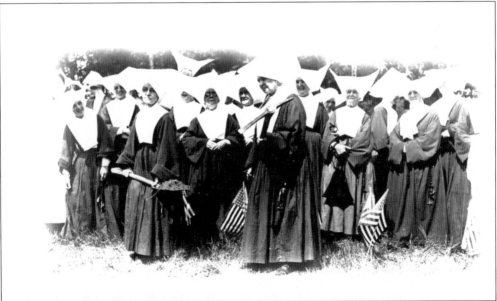

On August 27, 1927, Sister Dolores Gillespie (with shovel) led the ground-breaking ceremonies for Seton Hall, a new residence for the St. Mary's Hospital School of Nursing. Sister Gillespie was administrator at the hospital from 1904 to 1927. A native of Chicago, she was born in 1867 and joined the Daughters of Charity in 1888. Sister Dolores and her fellow sisters worked around the clock tending to the sick and dying of Milwaukee during the 1918 flu epidemic. (Photo courtesy of the Daughters of Charity archives, Evansville, Indiana.)

The daughter of longtime Milwaukee County District Attorney William James McCauley and his wife Mercedes O'Brien is seen here. Sister Mary McCauley was born in 1938, attending St. Ann Elementary and Holy Angels high schools. She entered the Sisters of Charity, BVM, in 1956, going on to teach and to direct health care facilities at sites around the country. In 2002, she began serving as pastoral minister for St. Mary, St. Patrick, and St. Bridget parishes in northeastern Iowa. (Photo courtesy of Sister Mary McCauley, BVM.)

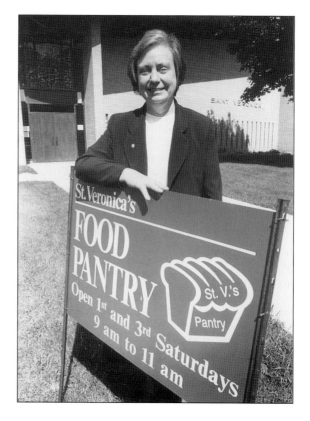

Sister Therese MacKinnon, a pastoral associate at St. Veronica Parish on Milwaukee's South Side, can trace her Irish heritage through the Cullens of Rucocin, Ireland, and the Martins of County Meath. She joined the Daughters of Charity in 1965. Sister MacKinnon was honored with the 2003 "Women Helping Women" award for establishing a food pantry and for her outreach ministry to the poor. The award was made by Soroptimist International, which annually recognizes local leaders for servicing community needs. (Photo by author, courtesy of The Irish American Post.)

Four

THE SCHOOLS
"YES, SISTER." AND "NO, SISTER."

The love of learning runs deep throughout the Milwaukee Irish community. Many immigrants who never completed much schooling insisted that their children strive for a higher education. Even if they lived in rural areas or smaller Wisconsin towns, young people from throughout the area made their way to the city, drawn by the lure of Marquette University and other schools. They stayed, raised families and became integral parts of the community. Many moved on to impact the wider world.

Their children attended parochial grade schools and then enrolled in Marquette University High School or any of the other marvelous private high schools in town, as well as making their mark in the public system. Irish American educators, both in the management and teaching ranks, made sure that minds were exercised and that passion for improvement was continually fueled. As early as the 1840s, dedicated sisters, lay teachers and priests were already leading the way.

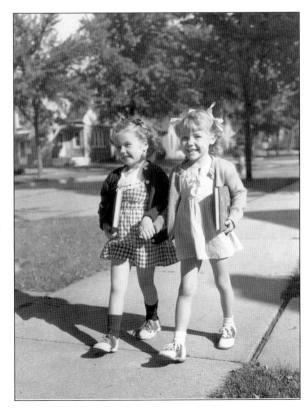

On the first day of school, Mary Pat Russell (left) and her friend, Juzie Humholz, are ready for another year. Her great-grandfather, Patrick, had emigrated from Ireland to Wisconsin in 1839. Mary Pat eventually went on to organize a school for the families of diplomats, community leaders, and international executives in Mexico City. She remains active in Irish-Mexican affairs in Mexico and returns regularly to revisit her Milwaukee Irish roots. (Photo by Ray Humholz courtesy of the Russell family.)

Sisters and youngsters at the St. Vincent's Infant Home gathered for a photo outside the building on South Third Street and Greenfield on March 27, 1879. The home opened in 1877 as a refuge for unwed mothers and orphaned infants. Sister Mary Joseph Melody, superior at St. Mary's Hospital, had lobbied the Milwaukee Common Council for help in establishing a place for foundlings. Sister Camilla O'Keefe, superior of St. Rose's Orphanage, selected and purchased the building site. The infant home remained open until 1958. The corporation then became St. Vincent's Group Home, a social service agency working with adolescent girls experiencing emotional difficulties. It merged with St. Mary's Hospital in 1970. (Photo courtesy of the Daughters of Charity archives, Evansville, Indiana.)

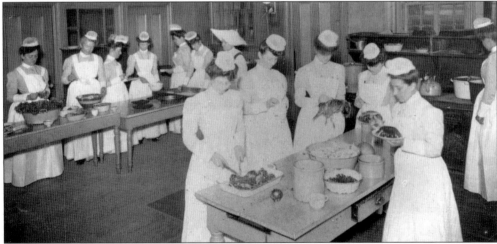

Around 1900, young women enrolled at the St. Mary's Hospital School of Nursing had to fix meals in addition to their many other tasks. After graduation, they would quickly be on the front lines of the city's medical world, caring for the community's elderly, sick, and suffering. Many of the area's Irish families sent their daughters to the school. (Photo courtesy of the Daughters of Charity archives, Evansville, Indiana)

Attorney James A. Sheridan, a long-time teacher, school principal, and superintendent in Wisconsin, became state inspector of schools in 1893. When he moved to Milwaukee in 1895, he resigned from that position to practice law. Retaining his love of education, Sheridan was president of the Milwaukee school board for one term and served six years as a board member. His wife, Harriet, was also a teacher, noted suffragette leader, and outspoken adherent of the League of Nations. Sheridan died October 13, 1912. (Photo from *History of Milwaukee, 1922* from the Sheldon Solochek collection.)

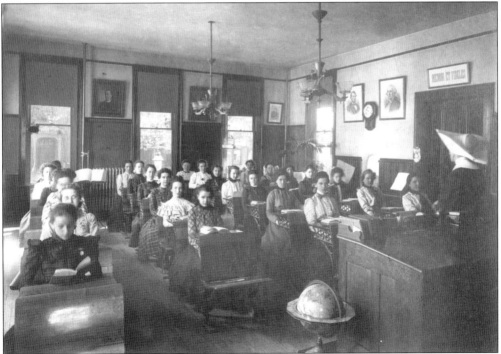

Each girl in this class at St. John's Cathedral High School around 1893 was ready to learn, under the watchful eye of a Daughter of Charity. (Photo courtesy of the Daughters of Charity archives, Evansville, Indiana.)

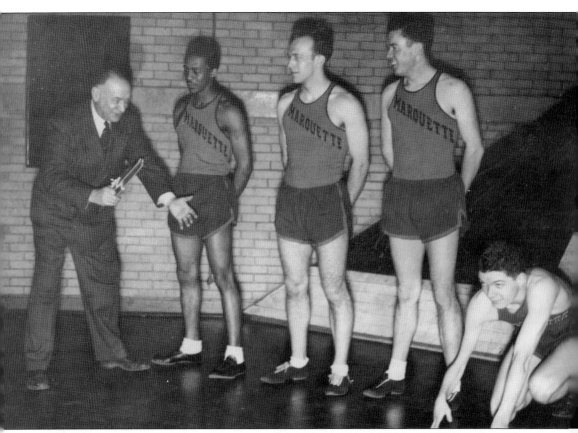

Conrad Jennings was Marquette University athletic director from 1926 to 1956. Brought on board as track coach in 1922, Jennings continued serving in that position until 1948. Here, in 1942, he provides some fine points to several of his runners. In addition to coaching such stars as Ralph Metcalfe and Milt Trost, Jenning brought national AAU games, NCAA tourneys and Olympic Decathlon Trials to Marquette. He is in several sports halls of fame for work supporting athletics. (Photo courtesy of the Marquette University archives.)

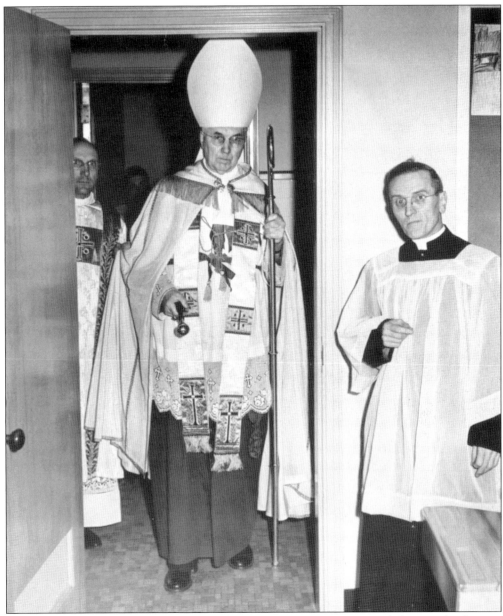

Milwaukee Archbishop Moses E. Kiley makes an imposing entrance at a dedication for the new school at Immaculate Conception parish in 1951. In 1870, the Milwaukee Iron Company in Bay View donated three lots at the corner of Kinnickinnic and Russell avenues for the purpose of building a Catholic church to serve its workers. James Carmody, James McIver, John Kidnay, Ambrose McGuigan and William Haney were on the initial fund-raising committee. The men of the new parish wanted the name of St. Patrick's, but the women favored Immaculate Conception and won a voting contest to select a patron. Obviously, the ladies in the Quirk, Shanahan, Galligan, Hurley, McGraw, Cauley, Clancy, and other Irish families in the neighborhood got the final say. The parish's first school was built in 1886, with five youngsters being in first graduation class in 1891. In its early years, the school was free to children of the parish. (Photo courtesy of the Archdiocese of Milwaukee Archives and Immaculate Conception parish.)

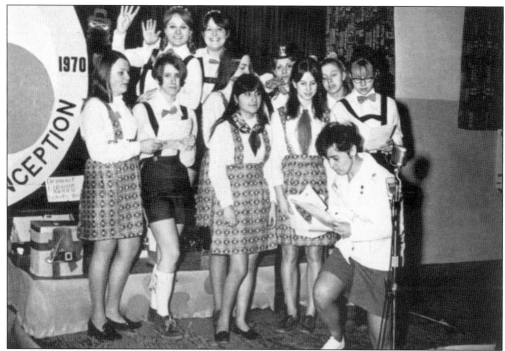

In 1970, Girl Scouts lead a songfest at the St. Patrick's Day Dinner at Immaculate Conception Parish. The annual event is put on by the St. Anne's Society. (Photo courtesy of the Archdiocese of Milwaukee Archives and Immaculate Conception parish.)

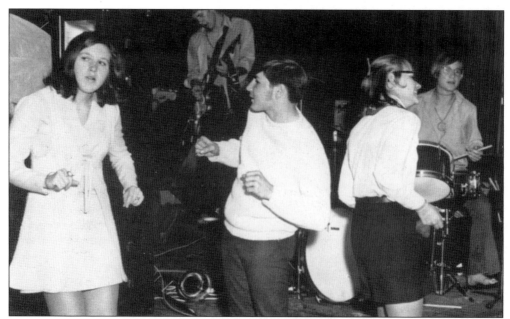

Swinging CYO dances at Immaculate Conception parish in the 1970s show that it wasn't all work and no play at the Bay View school. Popular local bands were a big draw, providing the beat for showing off the latest steps. (Photo courtesy of the Archdiocese of Milwaukee Archives and Immaculate Conception parish.)

Robert L. Cooley, born in 1869, was a prominent Milwaukee educator and a founder of the Milwaukee Vocational School. He taught at several schools around Wisconsin before moving to Milwaukee in 1903 to become a principal in the city's public school system. He was named director of vocational schools in 1912. The vocational tech. school that he helped organize is now the Milwaukee Area Technical College. (Photo from *History of Milwaukee, 1922,* from the Sheldon Solochek collection.)

A former New York City teacher, Edward A. Fitzpatrick, became a nationally known educator. In 1913, he drafted Wisconsin's first minimum wage law for teachers while investigating state educational systems. Fitzpatrick remained in the state to manage its draft program during World War I. In 1924, he became dean of the graduate school at Marquette University and acted as educational director for its college hospital administration between 1924 and 1926. Fitzpatrick then served as president of Milwaukee's Mount Mary College from 1929 to 1954. Born in 1884, he died in 1960. (Photo courtesy of Mount Mary College.)

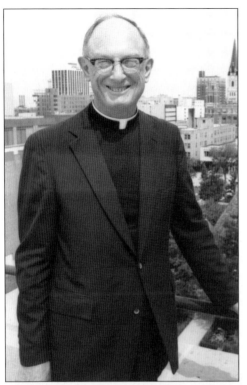

Father John P. Raynor stood atop a Marquette University roof, with the downtown Milwaukee skyline ranging behind him. Raynor was president of the school from 1965 to 1990, the longest of any president in Marquette's 120-year-plus history. It is estimated that more than half of the university's 96,000 living alumni graduated during his presidency. During his years at the helm, Marquette grew from 26 acres to about 80 acres and added numerous departments and educational programs. After his retirement, he became university chancellor. Raynor died in 1997. (Photo courtesy of Marquette University archives.)

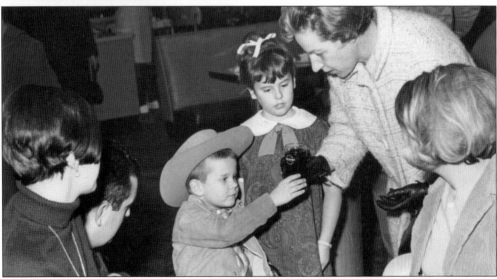

Mary Alice Cannon was dean of women at Marquette University from 1958 to 1969, before moving on to vice presidencies at several other Catholic universities around the Midwest. She returned to Milwaukee to become director of personnel for Milwaukee County from 1979–1983, becoming the first woman cabinet officer in Milwaukee County government. She oversaw the personnel aspects of 11,000 county employees. Cannon could trace her family back to Denis Cannon and Susanna Sweeney of Rosbeg, County Donegal, who left Ireland in 1832 to come to Wisconsin. Her brother Robert was a noted Milwaukee lawyer and judge. (Photo courtesy of Marquette University archives.)

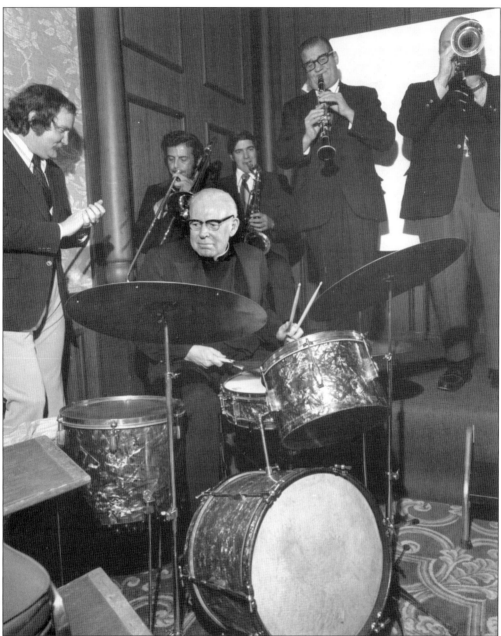

Always marching to his own beat, Father Edward J. O'Donnell was Marquette University's youngest president. He took the university reins in 1948 at age 39, serving until 1962. Born in Milwaukee, O'Donnell attended Gesu Grade School and played football for Marquette University High School. When he retired from Marquette, O'Donnell was named chancellor and a school trustee. Under his 13-plus year administration, he built a College of Business Administration, two libraries and a new union. In this 1972 photo, O'Donnell played his drums at a party in the Pfister Hotel. He died in 1986. O'Donnell was cousin of former Milwaukee County Executive William F. O'Donnell, Clerk of Courts Francis X. McCormack, and County Treasurers John P. McCormack and his brother Paul J. McCormack. (Photo courtesy of Marquette University archives.)

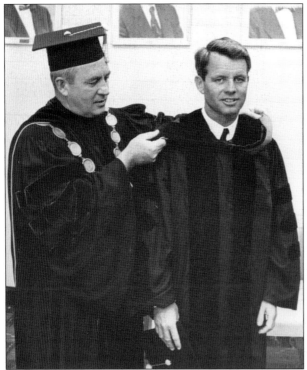

Attorney General. Robert F. Kennedy is helped with his gown by Father William F. Kelley, president of Marquette University. Kennedy was at the Milwaukee Arena in 1964 to deliver the school's commencement address and receive an honorary degree. He spent so much time answering questions at the end of the event that he had to rush to the airport still wearing the gown. An aide was sent to retrieve his coat. (Photo courtesy of Marquette University archives.)

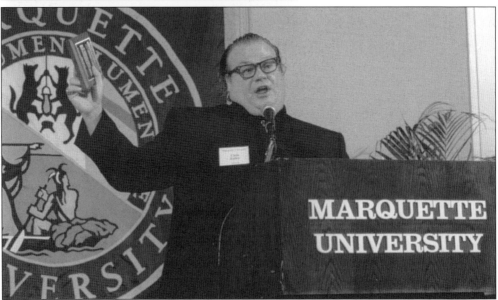

Comic Chris Farley hams it up while receiving Marquette University's Young Alumnus Award from the College of Communications in 1996. Farley graduated from the university in 1986 with a degree in communications and theater. While at the school, the Madison-native described himself as a "teacher's nightmare." After Marquette, Farley did improv comedy at Chicago's Second City and went on to star on television's *Saturday Night Live* during the 1990s. He made numerous films, many of which used inside family jokes honed during his growing up years. Farley died at age 33 in 1997. (Photo courtesy of Marquette University archives.)

A love affair with the Midwest remained an integral part of Marjorie (Mo) Mowlam since her student days at the University of Iowa and her position as associate professor of political science at the University of Wisconsin-Milwaukee in the 1970s. "Those were the best years of my life," she once said in an interview with *The Irish American Post*. Even when Mowlam was the secretary of state for Northern Ireland secretary of state between 1997 and 1999, she would affirm that "there's a soft spot in my heart for UWM. After class, I'd go home and sit on—what do you call it?—the stoop, the porch, and have a beer. But I mostly remember the color, those wonderful soft colors as the sun filters through the leaves. It was most calming." Mowlam was also a member of the British Parliament, as well as serving in Tony Blair's cabinet. (Photo by John Alley, courtesy of *The Irish American Post*.)

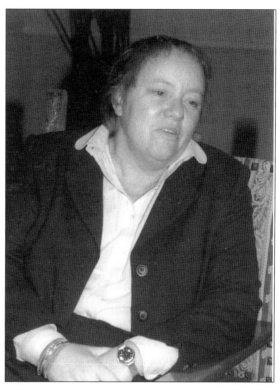

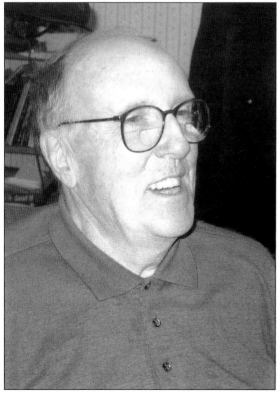

Daniel Maguire, a Marquette University theology professor, has actively sought to promote social justice and international peace through his long career in education. Maguire is the youngest of seven children—all were born in County Donegal except himself, being born in Philadelphia in 1931. Author of numerous books and an international lecturer, Maguire is also president of the Religious Consultation on Population, Reproductive Health, and Ethics. (Photo courtesy of Dan Maguire.)

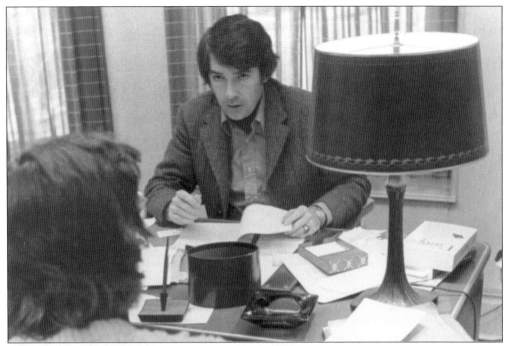

Professor Tom Hachey, shown during his early teaching days at Marquette University, went on to become the school's dean of arts and sciences in 1993. Active in Irish American educational circles, Hachey then became the first executive director of Irish programs at Boston College in 2000. (Photo courtesy of Marquette University archives.)

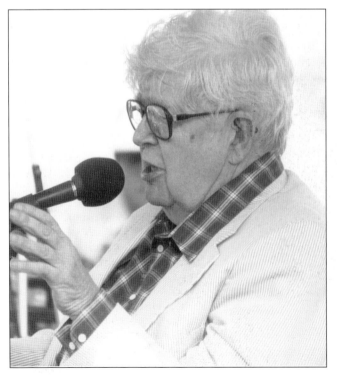

George Reedy leads a spirited political discussion at one of the Milwaukee Irish Fest hedge schools in the late 1980s. A former UPI reporter, Reedy was Lyndon B. Johnson's press secretary as Senate leader, vice-president, and then president after John F. Kennedy was assassinated. He left Johnson's staff over disagreements about the Johnson's handling of the Vietnam War. Reedy served as Marquette University journalism dean from 1972 to 1977, continuing to teach until 1990. He died in 1999. (Photo by author, courtesy of Milwaukee Irish Fest.)

Presidential candidate John F. Kennedy made a big hit when he visited Pius XI High School. Signing autographs and shaking hands, he made his way through the hallways, charming everyone in sight. (Photo courtesy of Pius XI High School.)

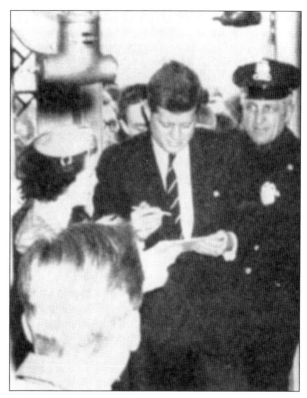

Father Lawrence McCall was the much beloved principal of Pius XI High School from 1964 to 1990. He was instrumental in advancing the cause of Catholic higher education, but also reached other faith communities to encourage a broad enrollment in the school. Pius was founded in 1929 by priests and staffed by the School Sisters of St. Francis for many years. (Photo courtesy of Pius XI High School.)

Musician/storyteller Celia Farran enthralls youngsters with tales in the oral tradition of the seanachie. Farran has performed in one-woman shows off-Broadway and elsewhere throughout the country, as well as in Milwaukee. Her first CD, *Fire In the Head,* in 2000, was a collection of mostly classic Irish songs and her second, *Breathe,* was a more eclectic collection released in 2003. Farran comes from a strong family performers. Her mother Cecilia helped start the Milwaukee Irish Fest Summer School and has long been active in promoting Celtic music. Her brothers, Marty and Brian Grinwald, perform in their bluegrass group, the Brothers Grin. (Photo courtesy by Anna Simsek Grinwald.)

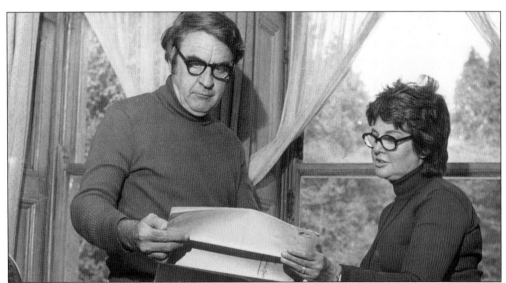

Gareth and Janet Dunleavy were longtime English professors at the University of Wisconsin-Milwaukee, specializing in Irish and British literature. Noted scholars and writers, they produced numerous books and articles about Irish cultural and political leaders. One of their most critically acclaimed works focused on Douglas Hyde, elected first president of modern Ireland in 1938. In this 1975 photo, the couple review papers at Clonalis House, Castlerea County Roscommon. (Photo by Robert J. Higgins, courtesy of the Shamrock Club of Wisconsin.)

Five

THE PROFESSIONS
POLITICIANS TO PUBLICANS

Irish names have cropped up in the entire spectrum of Milwaukee life over the years—especially in the honorable worlds of politics, journalism and, of course, pub management. The roster then rolls on to attorneys, judges, physicians, butchers, bakers, and baggage handlers. The mix of one with one or both of the other always means fun.

The old Irish in Milwaukee were serious about their duties at the bar...and not just in the pub. Atty. Kate Kane came to Milwaukee in 1875 and became a leading spokeswoman for women's political equality. Hugh Ryan was a longtime Milwaukee-based U.S. court commissioner in the 1870s. Chief Justice Edward G. Ryan was born in County Meath in 1810 and moved to Milwaukee in 1846. He was city attorney from 1870 to 1872 and appointed to the State Supreme Court in 1874, being called "one of the most brilliant lights on the bench."

Old Milwaukee Irish families are linked in many ways. A reporter once referred to the Cannon family as "a legal dynasty." Judge Robert Cannon was a second cousin (on his father's side) to Circuit Court judges David V. Jennings and Leander J. Foley. He was also a second cousin (on his mother's side) to John J. Fleming, longtime city attorney of Milwaukee, and his brother, Ray Fleming, who was a Milwaukee alderman and clerk of courts. Cannon & Dunphy, partnered by one of Cannon's sons, Bill, is among the city's best known law firms. Thus, the Cannons are connected by blood to several of Milwaukee's outstanding Irish political families. The Cannons originally hail from Rosbeg, County Donegal.

Now speaking of the other type of bar, Milwaukee's long-ago publicans are well noted. Big Bill Delaney ran a tough drinking house at 1110 Hill Street, but his wife, Nellie O'Connell, kept a close watch on Himself. Killarney-born Jimmy Hogan had a place at 162 Menomonee, joined the Hibernian Benevolent Society and married Mary McGrath, which barely slowed him down. James Foley became a firefighter in 1868, was member of the Common Council from the Irish Third Ward and ran a saloon at 421 E. Water St. , thereby ensuring that all his bases were covered.

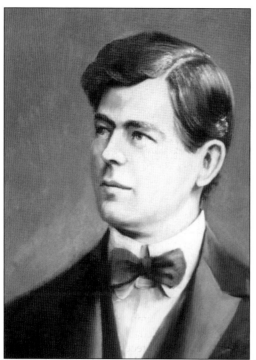

Cornelius (Connie Da Cork) Corcoran was Third Ward alderman from 1892 to 1935, thereby holding the record for the longest tenure on the Milwaukee Common Council. For 30 of those years, he was council president. When the incumbent was out of town, Corcoran was acting mayor. Even as the Ward became more Italian than Irish, he held his own garnering votes being known in some quarters as Cornelio Da Cork. (Photo courtesy of the Milwaukee Common Council.)

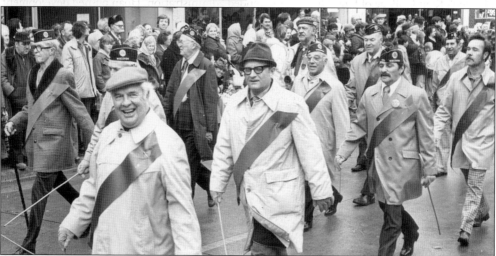

Every politician loves a parade, as witnessed by this St. Patrick's procession in the 1970s led by a smiling County Executive John Doyne. Directly behind him is Tom Ament, who would become the fourth county executive in 1992. The Wisconsin legislature created the position in 1960, with Doyne being the first person elected to that role. The Milwaukee Regional Medical Center—which brought together several area major medical facilities together on the county grounds in Wauwatosa—was created under his administration. Doyne graduated with a law degree from Marquette University in 1937. In 1940, he won election to the state Assembly as a Democrat. Doyne was followed into the exec's office in 1976 by William F. O'Donnell. Before the executive's position was created, the most powerful political figure in the county was the board chairman, such as William E. McCarty who ran the show as chair from 1914–1932. (Photo by Robert J. Higgins, courtesy of the Shamrock Club of Wisconsin.)

Daniel Webster Hoan was Milwaukee's Socialist mayor from 1916 to 1940, making him the one of the longest serving city leaders in the country. Prior to becoming mayor, Hoan was city attorney from 1910 to 1914. He knew life from the rough side, having earned college tuition as a cook. Hoan graduated from the University of Wisconsin in 1905, receiving a law degree from Chicago's Kent College of Law. Under his extended administration, Hoan pushed development of parks, the airport, harbor expansion, water filtration projects, and housing programs. His family name was originally "Horan" but his father dropped the "r." (Photo courtesy of the Milwaukee County Historical Society.)

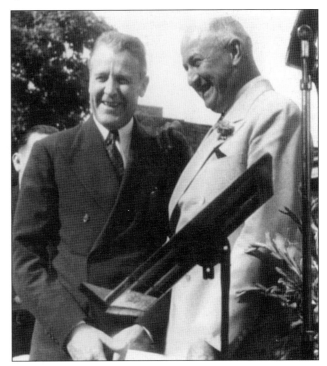

John Cudahy was a distinguished Milwaukee-born statesman who was US ambassador to Poland from 1933 to 1937 and the first US ambassador to the Irish Free State from 1937 to 1940. He then represented US interests in Belgium and Luxembourg in 1940 as World War II broke out. His father was Patrick Cudahy, one of the founders of the Cudahy meat packing dynasty. In this 1931 photo, Cudahy (left) meets with businessman James Farley, chairman of the Democratic National Committee in the 1930s. (Photo courtesy of Michael Cudahy.)

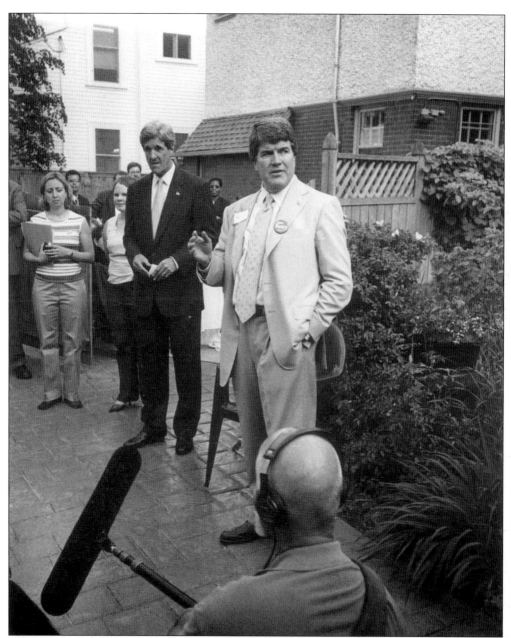

At a party in the backyard of his East Side Milwaukee home in the summer of 2003, lawyer Matt Flynn introduces Democratic presidential candidate Senator John Kerry of Massachusetts. Flynn, chair of the Wisconsin Democratic Party from 1981 to 1985, is a commercial litigation attorney at Quarles & Brady. He was also Milwaukee County chairman for the Ted Kennedy primary campaign in 1980. The eldest of 11 children, Flynn's father's family came to America in the 1870s. His mother's family were Monahans and Brocks from Cork. His father, Gerard, moved to Milwaukee in 1963 as an assistant professor in Spanish at the University of Wisconsin-Milwaukee. Flynn himself has a bachelor's degree in Spanish from Yale (1969) and received his law degree in 1975 from the University of Wisconsin-Madison. (Photo by author, courtesy of *The Irish American Post*.)

The dean of Milwaukee pub owners, Derry Hegarty, has a chat with Alderman Michael Murphy at a political-do in his Bluemound Road watering hole. Hegarty's has long been the city's primary meeting place for political fund raisers and election night *hoolies*. Weddings, funeral dinners, retirement parties, and meetings of Irish organizations are also regularly held there. Hegarty was born near Cork and both of Murphy's parents are from Dublin. (Photo by the author, courtesy of *The Irish American Post*.)

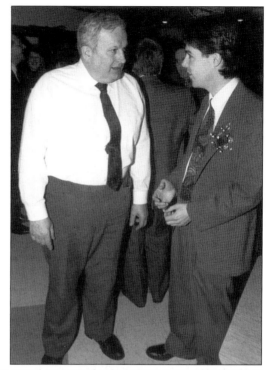

Ray Flynn (seated right), three-time mayor of Boston, dropped in at Kit Nash's Irish Castle on Milwaukee's South Side to drum up pre-election support for Democratic presidential candidate Bill Clinton. Flynn would eventually go on to be Clinton's ambassador to the Vatican. Dublin-born Nash, the Himself, gave a grin as the pints went 'round. Joining them were Mayor John Norquist (standing left) and former alderman Kevin O'Connor. (Photo by John Alley, courtesy of *The Irish American Post*.)

This cartoon of Attorney Raymond J. Cannon shows him practicing law when he was a partner in the firm of Cannon & Waldron (1914–1929). His baseball connection is depicted, as well. In 1919, Cannon represented "Shoeless Joe" Jackson, a Chicago "Black Sox" player implicated in a 1919 scandal swirling around that year's World Series. Even while practicing law, Cannon was also a semi-pro baseball player from 1908 to 1922. Born August 26, 1890, Cannon was admitted to the Milwaukee bar in 1914, after graduating from Marquette Law School. He served three terms in Congress (1933–1939) and was a Roosevelt delegate-at-large to the 1936 Democratic convention. After his congressional run, Cannon practiced law in Milwaukee from 1939 to 1951. He died November 25, 1951. (Sketch from the Milwaukee Newspapers Artists Club, from the collection of the Feerick family.)

Four generations of the Cannon "legal" family of Milwaukee are shown here. Judge Robert Carey Cannon (left) stands next to his son Attorney (and Irish historian/genealogist) Thomas Gildea Cannon, a partner in the O'Neil, Cannon & Hollman law firm. Seated is Tom's daughter Rachel M. Cannon, an assistant United States attorney in Chicago. She is holding a portrait of her great-grandfather, Congressman Raymond Cannon. Judge Robert Cannon was a noted civil and circuit court judge in Milwaukee County from 1945 to 1978. When he first went on the bench at age 27 in 1945, Cannon was the youngest judge in the nation. He was also a presiding judge for the Wisconsin Court of Appeals from 1978–1981 and a legal advisor for the Major League Baseball Players Association from 1959–1965. (Photo courtesy of Thomas Gildea Cannon.)

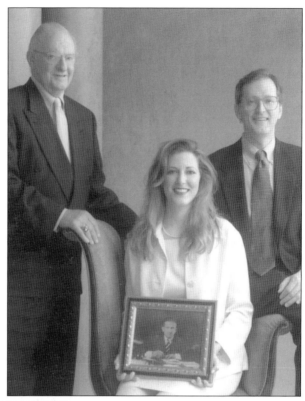

Michigan-born William James Patrick McCauley received his law degree from Marquette University in 1923. After practicing law in the city, he was named an assistant district attorney in 1933 and then served as Milwaukee County assistant district attorney from 1944 to 1964, starting a long run of Irish in the job. McCauley died four days before the election in which he was vying for his 11th term and was followed by Hugh O'Connell, who served until 1968. Governor Warren Knowles appointed David Cannon for a term from April, 1968 to January of 1969. Next came Michael McCann, who started his first term in 1969 and was still in office in 2003. (Photo courtesy of Sister Mary McCauley.)

Milwaukee County Executive William F. O'Donnell was always ready for a joke before buckling down to hard work. He served as exec from 1976 to 1988, after being a county supervisor for 28 years. A long-time resident of the working class Merrill Park neighborhood, O'Donnell was proud of his Irish roots. He annually hosted a walk over the Milwaukee harbor via the Dan Hoan Bridge to celebrate his birthday, which always occurred around the time of Milwaukee Irish Fest. (Photo by Paul Henning, courtesy of Milwaukee Irish Fest.)

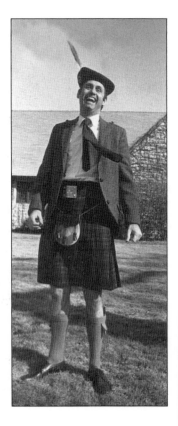

A kilt-clad Michael Sullivan enjoyed a good laugh during an outing of the Clan Donald, in which he is an active member. Sullivan also heartily celebrates his Gaelic background at Milwaukee's Irish Cultural & Heritage Center. Named chief judge of the Milwaukee County Circuit Court in 2003, he was the 1999 State Bar of Wisconsin Judge of the Year. (Photo by author, courtesy *The Irish American Post*.)

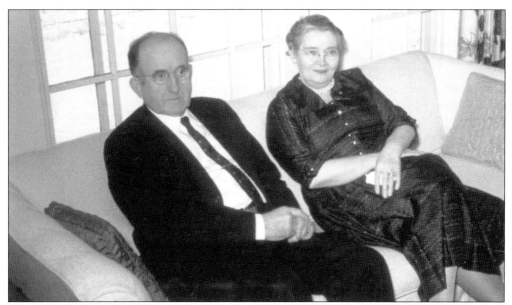

Edward H. Finnegan and his wife Catherine McGarty Finnegan were photographed in their home in 1962. Finnegan was a long-time Democratic activist in the Milwaukee area, starting with Franklin Delano Roosevelt's New Deal era and on into the 1960s. Finnegan, an engineer, was chairman of the Wauwatosa Democratic committee for many years and helped organize the city's Young Democratic Club. (Photo courtesy of Peg Finnegan Mirenda.)

Peg Finnegan Mirenda holds a book of raffle tickets for a 1932 Labor Day rally and picnic at State Fair Park at which she and her sister Helen sat on the lap of headliner Boston Mayor James Curley. The event was sponsored by the Democratic Committee of Milwaukee County. Mirenda's uncle, Mike McGarty, was Curley's physician and her dad, Ed Finnegan, was a major Democratic voice in Milwaukee. That September 4 also happened to be Mirenda's ninth birthday. Mirenda was on the faculty of Mount Mary College's occupational therapy department between 1955 and 1988 and was its chairman for 15 years. (Photo by author, courtesy of *The Irish American Post*.)

Charlie O'Neill started working for the St. Vincent de Paul Society at age 26 in 1939, accepting a $150 monthly salary. He eventually retired at age 71 as the group's executive secretary more than 45 years later. A native of Patch Grove, a village in western Wisconsin, O'Neill was a graduate in social service from the University of Notre Dame. Throughout the Depression, he helped many area churches find jobs, financial aid, and food for their out-of-work parishioners. He was also active in assisting for World War II displaced persons and Hungarian Revolution refugees. (Photo courtesy of Bruce O'Neill.)

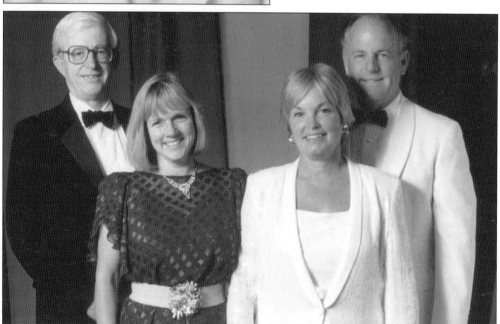

Celebrating the state's 150th birthday in 1998 at a party in Madison were, from left to right, Milwaukeeans William Fitzhugh Fox, his wife Karen, Kathryn (Murph) Burke, and her husband John. Fox, an attorney with Fox-O'Neill-Shannon SC, can trace his family back to County Offaly and is an active board member with the Milwaukee Foundation, Boys & Girls Clubs of Great Milwaukee, and the Great Circus Parade. Entrepreneur-philanthropist John Burke is a well-known Milwaukee developer who launched the Potawatomi Bingo Casino. Murph was chair of the Wisconsin Arts Board from 1990 to 1999. (Photo courtesy of the Fox family.)

Ned Russell was a sergeant in General George Patton's Hellcats tank unit during World War II. He returned from the front to open a bar called The Hillside on Fifth and Clybourn that was a great neighborhood hangout for such pals as Alderman Charlie Quirk of the Fourth Ward. Politically active in Democratic circles, Russell's nickname was "Car Top" because he usually sported some candidate's name atop his car. This photo is c. 1953. (Photo courtesy of Michael Neville.)

Cary (Rip) O'Dwanny received his nickname for his skill in batting baseballs as a kid on Milwaukee's East Side, not far from where he now operates the County Clare guest house. The County Clare, which opened in 1996, is a hotbed of Milwaukee Irishness. Long active in the hospitality business, O'Dwanny first renovated the 52 Stafford, an Irish inn in Plymouth, Wisconsin. Dating from 1892, the 52 Stafford is the oldest continuous operating hotel in Wisconsin. Each guest room is named after an historic Irish personality. O'Dwanny also owns Castledaly, a restored manor in Athlone, County Westmeath, and St. Brendan's Inn in Green Bay, Wisconsin. (Photo by Dan Hintz, courtesy of *The Irish American Post*.)

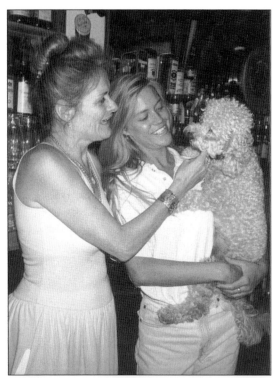

It was a natural for Annie James (left) to operate a pub appropriately called The Dubliner. After all, she hails from the Libertieis in Dublin. Adorned with dozens of historic Irish photos, her Walker's Point pub opened in September, 1996, and closed in the early 2000s. The Dubliner was noted for its regular *sessiuns* and for hosting numerous local and traveling Irish bands. Here, James and her daughter Peggy play with their dog Bailey. (Photo by author, courtesy of *The Irish American Post*.)

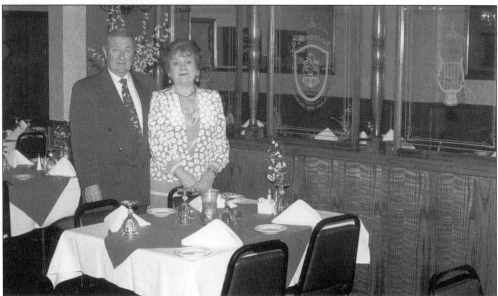

Danny and Helen O'Donoghue stand proudly in the main dining room of their restaurant, which they operated on Blue Mound Road from 1986 to 1996. Coming to Milwaukee from Killarney in 1949, O'Donoghue owned a popular State Street bar for a number of years, even while working as a laborer and foreman at Miller Brewing Company. He partnered for a time with his uncle Big Jim Hegarty, a County Corkman who was then "chieftain" of the Milwaukee Irish bar owners. The O'Donoghue's son, Jamie, owns an bar in suburban Elm Grove featuring *sessuins* and set dancing. (Photo courtesy of *The Irish American Post*.)

The late, lamented Black Shamrock on Milwaukee's East Side, and Celia's Pub, managed by Kerry Wiedemann on South Second Street in Walker's Point, attracted large crowds in the 1990s. Music, poetry, readings, and theatrical presentations were part of the scene at both places. Owner Tom Connolly stood outside his Black Shamrock, always on the alert for a passing muse. (Photo by author, courtesy of *The Irish American Post*.)

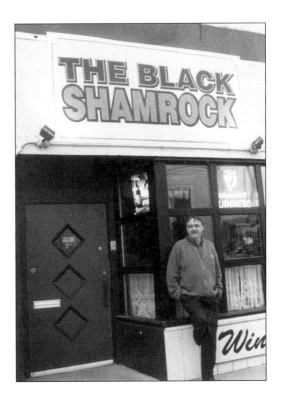

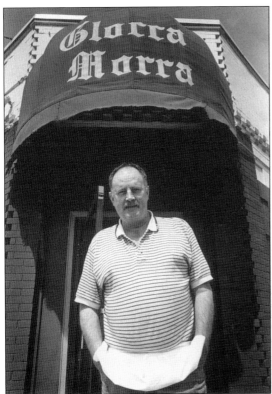

Joe Hegarty emigrated from Drinagh, County Cork in 1965 and was almost immediately drafted into the U.S. Army. He served as an E-4 in the artillery, fighting in the Central Highlands of Vietnam. Discharged in 1968, Hegarty went on to get a business degree from the University of Wisconsin-Milwaukee and opened the Glocca Morra pub near the Marquette University campus in 1976. (Photo by author, courtesy of *The Irish American Post*.)

David Trimble, chairman of the Ulster Unionist Party, is interviewed in 1998 by Derry-born Malcolm McDowell Woods, managing editor of *The Irish American Post*. Trimble was in Milwaukee that year for the Kennan Forum, an annual round of intense, timely discussions in honor of the late United States diplomat George F. Kennan, a Milwaukee native. *The Post* had lent its support to the University of Wisconsin-Milwaukee in setting up the program that resulted in Trimble's "Milwaukee Doctrine," aimed at heading off continued violence in the North. (Photo by John Alley, courtesy of *The Irish American Post*.)

Fergal Gallagher was 18 years old when he came to Milwaukee from Stillorgan, County Dublin in 1956. Gallagher received a doctorate in English in 1968 from the University of Wisconsin-Madison and then began teaching. In the mid-1980s, he joined Dr. Sean Keane (aka John Brown) in hosting *Radio Erin*. Eventually, Gallagher took over the show, which lasted until 2002. While on the air, he interviewed dozens of notable Irish and Irish American politicians, entertainers and cultural leaders. (Photo courtesy of Fergal Gallagher.)

Bob O'Meara bounces son Dave on his knee in this shot from 1954. The senior O'Meara was a longtime Milwaukee journalist who worked for the Associated Press between 1948 and 1987, covering some of the area's biggest stories of the era. Young O'Meara became active in Milwaukee Irish Arts, as well as presenting his own one-man shows. He was also producer and writer for *Hotel Milwaukee*, the award-winning comedy- variety program appearing on Wisconsin Public Radio. (Photo by Robert J. Higgins, courtesy of Dave O'Meara.)

Joe Dorsey, ever popular on-air raconteur for WOKY-AM, lays on the blarney on St. Patrick's Day, 1973, when he received the Shamrock Club of Wisconsin Irishman of the Year award. (Photo by Robert J. Higgins, courtesy of the Shamrock Club of Wisconsin.)

Robert J. (Bob) Riordan jots notes for a breaking story in the 1940s while a reporter for the Hearst-owned *Milwaukee Sentinel*. During World War II, he was an F.B.I. agent, returning to the paper after service. When *The Milwaukee Journal* bought the *Sentinel* in 1962, Riordan became editor of *Let's See* and *Milwaukee* magazines. He then managed policy holder relations at Northwestern Mutual Life Insurance. Riordan was elected to the Milwaukee Press Club Hall of Fame in 1985. (Photo courtesy of Sue Riordan.)

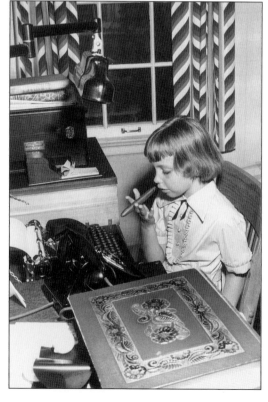

Sue Riordan seems to be asking which end is which on one of her father's cigars. Settled in at the typewriter, Riordan was all set to follow dad Bob's footsteps as a journalist. She became a pioneer female broadcast reporter in Milwaukee, being the first woman to deliver editorials at WITI-TV. She was the first female press secretary for a Wisconsin governor and was director of media and public relations at Wisconsin Gas from 1983 until her retirement in 1999. (Photo courtesy of Sue Riordan.)

With the panorama of Glacier National Park behind him, *Milwaukee Journal-Sentinel* travel columnist Dennis McCann paused on one of his journeys. McCann's Irish lineage includes Durans, Skellys, and Joyces, with his family coming to Rock County, Wisconsin, in the 1850s. McCann joined the paper in 1983. His 25th wedding anniversary trip to Ireland with wife Barbara was "a success despite the language barrier." (Photo courtesy of Dennis McCann.)

Photographer John Alley shivered in the Antarctic cold while on an assignment in 1963. Born in Rome, N.Y., of a long line of railroad workers originally from County Westmeath, Alley is longtime photojournalist who also worked for the government of Samoa. He directed the University of Wisconsin photography department and was head photographer for the Wisconsin Gas Company. He is the chief photographer for *The Irish American Post* and is active with Scottish and Irish cultural and social organizations. (Photo courtesy of John Alley.)

Josie Nash of Nash's Irish Castle receives a warm hug from Finbar MacCarthy, who first began singing Irish folk music in Dublin pubs at age of 12. He, his wife Gloria, and their three children left Dublin in the early 1980s, as he performed in the Canary Islands and elsewhere around Europe. The family then moved to Wisconsin where he owns a bar in Saukville, a small town north of Milwaukee. The late Kit and Josie Nash were both born in Dublin and were the principal advocates of Irish music when they settled in Milwaukee and opened the Irish Castle. (Photo by John Alley, courtesy of *The Irish American Post*.)

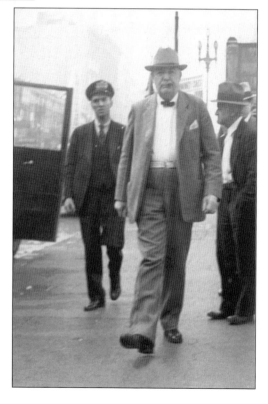

Stanislaus Lalumiere Sullivan strides purposefully down a Milwaukee sidewalk in the 1930s. Sullivan was born in Milwaukee in 1868 and was baptized at the old St. Gall church, where he was christened with the names of the parish priest at the time. Sullivan married Annie McBride in 1894 at St. John the Evangelist Cathedral. The long-time Chicago-St. Paul-Northwestern Road baggage handler died in 1943. (Photo courtesy of Bill Sullivan.)

Dr. John T. Sullivan, a native of Peoria, Illinois, entered the Marquette University Medical College in 1911 and received his degree in 1913. But before attending MU, he played professional baseball with the Cincinnati Reds and in Louisville. Setting up practice at 1030 North Avenue, he quickly became the doctor for many of Milwaukee's notable Irish families and was on the staff of Trinity Hospital. Sullivan was also active with the Knights of Columbus. (Photo from *History of Milwaukee*, 1922, courtesy of the Sheldon Solochek collection.)

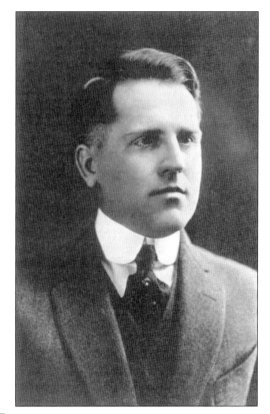

In 1994, Milwaukee psychiatrist Dr. Basil Jackson received a secret phone call, requesting his help in reconciling differences between parties conferring on the cease-fire in Northern Ireland. As such, he was one of the first to know of the pending talks between the hardline republican and loyalist factions there. Belfast-born Jackson received his medical degree in 1957 at Queen's University in Belfast and interned at Banbridge General Hospital in Northern Ireland. He received the Musgrave Prize in pathology from Queen's University. He came to Milwaukee in 1964 as a psychiatric consultant to Milwaukee County Children's Court. (Photo courtesy of Dr. Basil Jackson.)

Alderman Wayne Frank waves from a carriage on the way to an Irish Fest promotion in 1989. Frank eventually left the Milwaukee Common Council to pursue his dream of being a playwright, writing about Vietnam, and the Irish neighborhood of Merrill Park. He was instrumental in helping put together the city's International Arts Festival which focused on the Irish in 1999. (Photo by author, courtesy of Milwaukee Irish Fest.)

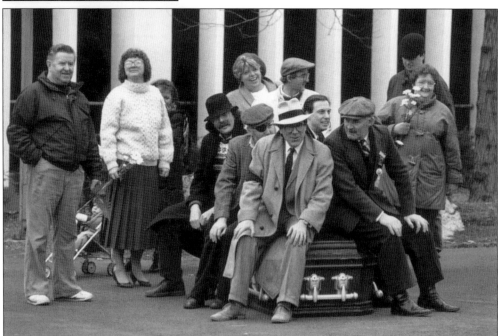

Mourners from the Irish Fest theater company carrying the "remains" of Grandma Scanlon took a short break on their sad journey. They were carrying the casket from the Harp Pub to the Performing Arts Center prior to the staging of *The Wake* by Steve Allen in 1992. The production, directed by Chicago's Pat Nugent at the PAC, played to nearly full houses. (Photo by author, courtesy of Milwaukee Irish Fest.)

Six

WE AIM TO SERVE

Milwaukee's Irish men and women have always been ready to serve their community and country, whether in the military, police, or as a firefighter. Richard J. Nolan, an Irish-born soldier who once lived in Milwaukee, received the Congressional Medal of Honor in 1891. The honor was bestowed on the farrier from Company I, 7th U.S. Cavalry, who was cited for bravery in a battle with the Sioux at White Clay Creek. The deadly fracus took place in the wild borderlands between Nebraska and the Dakota Territory on December 30, 1890.

But well before that time, Milwaukeeans answered the call. Serving in a militia unit was part of the city's social whirl, in addition to being an important civic duty. The Milwaukee City Guards were the city's first Irish company, established in 1848 under the command of Captain McMannman. Under a reorganization, the unit became the Milwaukee Union Sarsfield Guards, captained by John Jennings and aided by lieutenants E.M. McGarry and P. McDonough. Captain Edward O'Neill headed the Union Guards. During the Civil War, many Milwaukee Irish were in Wisconsin's famed Iron Brigade during the Civil War.

From there, Irish Milwaukeeans have been represented in all branches of the military, from China to Cuba and on to the world wars, Korea, Vietnam, Panama, and the Middle East.

Milwaukee's first fire company was organized in 1837, armed with buckets and axes. The "Neptune," a goose-necked hand pumper, was purchased in 1839, "amidst great rejoicing," according to the historians. One of the first large fires in the city occurred in 1851 along Water and Erie streets destroying the homes of a number of poor Irish families, as well as several businesses. Not everybody was in the firefighting business in those days. John O'Brien was arrested in 1854 for setting a paint store on fire, purportedly for insurance purposes. But others, like the popular Patrick McLaughlin, better served the community. He was appointed chief in 1867 by Mayor Edward O'Neill, who knew a stalwart Irishman when he saw him. Patrick Duffy, hose cart driver, was a native of Ireland and well known firefighter from the mid-1850s to the 1870s.

In the early days of the city, law and order was enforced by a village marshal. The Milwaukee police department was officially established in 1855, consisting of six men "known for their fighting qualities." Among them were L.G. Ryan, David Coughlin, and John Hardy. They needed to be tough, keeping an eye on the mugs who hung out at the Rising Sun Saloon in the Irish Third Ward. One of these first officers, James Rice, died in the *Lady Elgin* disaster.

Throughout the years, Milwaukee's Irish cops were on call when needed. Sergeant Albert Murray was among the officers capturing John Schrank, who tried to assassinate presidential candidate Theodore Roosevelt in Milwaukee in 1912. The roll call goes on.

Several Irish-named Americans served as Milwaukee County sheriffs, including Charles Larkin (1861–1862), Mike Walsh (1891–1892), Michael Dunn (1893–1894), William Carey (1905–1906), Lawrence McGreal (1913–1914), Joseph Shinners (1833–1936, 1941–1944), and George M. Hanley (1945–1948). Shinners was one of Milwaukee's most important and colorful political figures of his era, running for mayor as well as for sheriff. His earned the sobriquet "Baseball Bat" Shinners for helping put down labor disturbances at Allis-Chalmers in the 1940s. But Shinners was also deeply interested in rehabbing kids in trouble.

Dr. William Jerome Cronyn, a widely respected Milwaukee physician, was the son of Margaret and Robert Cronyn—a graduate of Dublin University. His mother was a native of Bandon, County Cork. During the American Civil War, William Cronyn enlisted in 30th Michigan Infantry at age 15. After being discharged in 1867, he went on to earn his medical degree. In the 1870s, he joined the Navy. In 1893, he moved to Milwaukee, where he became an assistant surgeon in Troop A, First Wisconsin Cavalry, the so-called "Light Horse Squadron" of the Wisconsin National Guard. Working with the Jesuits at Marquette, Cronyn also helped establish the Marquette Medical College. (Photo from *History of Milwaukee*, 1922, from the Sheldon Solochek collection.)

Troop A, the Light Horse Squadron of the Wisconsin National Guard, demonstrated its maneuvering in the mid-1930s. The unit was mustered into service in 1880 by General Edward E. Byrant, the state's adjutant-general. The unit, which at first consisted primarily of Civil War veterans, was commanded by Captain W.O. Collins and included numerous Irish Americans from Milwaukee. When labor disturbances broke out in the city's Menomonee Valley rail yards and in Bay View in 1886, the troop was called up to guard ammo transports and clear the streets. It also put down a labor riot in Oshkosh in 1898. (Photo courtesy of the Wisconsin Veterans Museum.)

A jaunty Eddie Burns is all set to join the Army Expeditionary Force during World War I. He was one of thousands of young Milwaukeeans called up to fight in Europe during the "war to end all wars." (Photo courtesy of Jane Russell Holzhauer.)

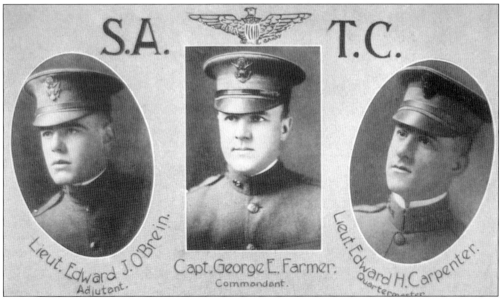

In 1919, the headquarters staff of the new Marquette University military program was commanded by Captain George Farmer. He was aided by adjutant Lieutenant Edward J. O'Brien, along with quartermaster Lieutenant Edward H. Carpenter. The idea of a Student Training Corps was advanced by General John (Black Jack) Pershing prior to the Armistice in Europe. Marquette's program was established at the school in October, 1918. About one thousand men volunteered either for the Army or Navy unit and were barracked around Milwaukee's West Side, including the Gesu gymnasium. (Photo courtesy of the Marquette University archives.)

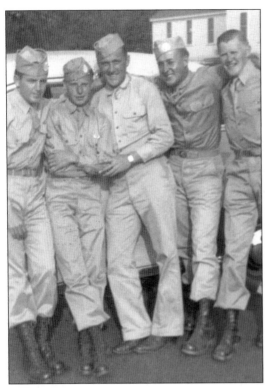

David Neville (center) partied with some of his Army buddies on leave during World War II. He was a rifle platoon leader in Company 1, 115th Infantry, 29th Division, during the Normandy Invasion. His company was surrounded during an attack on a German position but managed to fight free, although Neville was killed by a sniper. He is buried in the divisional cemetery near Insigny, France, and is one of the namesakes of the Neville-Dunn Post of the American Legion in Milwaukee. (Photo courtesy of Mike Neville.)

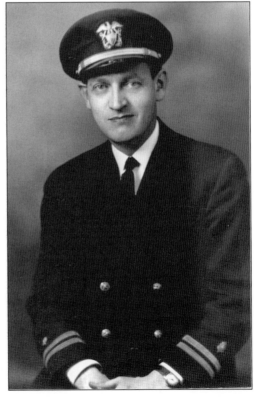

Dr. George William (Bill) Fox was born in Milwaukee on November 28, 1906, and graduated from Rush Medical College in Chicago. He practiced medicine at Milwaukee Children's Hospital and was also chief surgeon for the International Harvester County In 1942, he joined the Navy and became chief medical officer on the carrier *U.S.S. Franklin*. Fox was aboard the "*Big Ben*" on March 19, 1945, when it was attacked by Japanese kamikazes off the coast of Japan. Two bombs hit the *Franklin*, causing a great deal of damage and resulting in numerous casualties. Fox refused to leave the wounded in sick bay and was among the ship's 724 service personnel who died. For his bravery, Fox was awarded the Navy Cross. (Photo courtesy of William Fitzhugh Fox.)

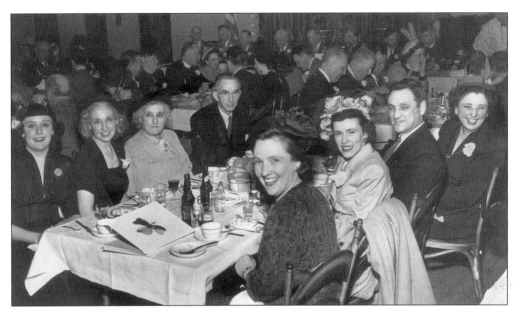

Enjoying a St. Patrick's Day party in the late 1940s at the Neville-Dunn American Legion Post were (clockwise from left to right) Ann Neville, Gertrude Neville Rastetter, Ann O'Connor Neville, Dr. Walter Rastetter (who became head of the student medical center at Marquette University in 1960s), Catherine Neville, Paul Neville, Ruth Russell Neville, and Dr. Mary Neville Bielefeld, one of the early woman graduates of the Marquette medical school. The Association of Marquette University Women annually gives an award in her honor for community service and career accomplishments. (Photo by C.W. Wilson, courtesy of Michael Neville.)

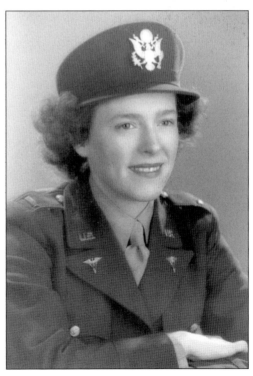

Army Lt. Ruth Russell was a nurse serving in London during the Blitz in World War II. Her sister Cecilia, also a nurse, was also based there at the same time. Both were graduates of Marquette University. After the war, Ruth returned to Milwaukee and married Paul Neville, working at International Harvester as industrial nurse in the 1950s and 1960s. Paul and Ruth's children were Michael, John, Sheila, Robert and David. (Photo courtesy of Michael Neville.)

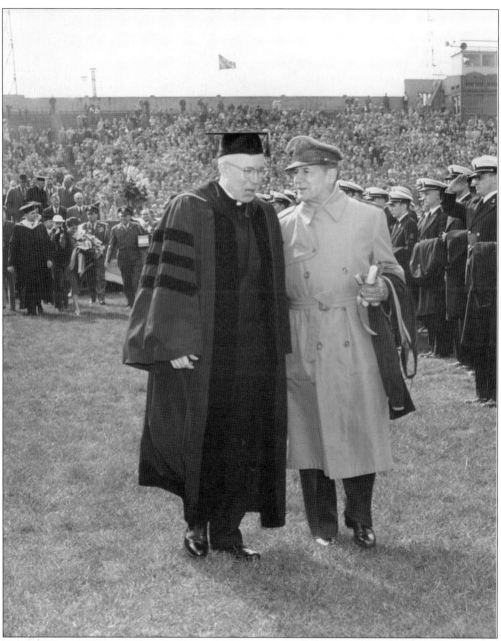

Father Edward O'Donnell, president of Marquette University, walks along while deep in conversation with General Douglas MacArthur. The general visited Milwaukee in 1951 and was given an honorary degree by Marquette University on April 27. Marking the occasion, a school holiday was declared. (Photo courtesy of the Marquette University archives.)

In 1957, Milwaukee Attorney Gerald P. (Jerry) Boyle was an Army first lieutenant in the artillery, becoming a captain in 1963 after graduating from Marquette Law School. He served as an assistant district attorney and deputy district attorney for Milwaukee County before going into private practice in 1968. Known for his flamboyant defense style, Boyle has had numerous high profile cases including representing Milwaukee cannibal Jeffrey Dahmer. In that 1992 case, he squared off against his former boss, D.A. E. Michael McCann. (Photo courtesy of Gerald P. Boyle.)

Infantry Captain Gerald Hugh (Jerry) Boyle stands outside his tent in Kuwait prior to being sent to Iraq, where he saw combat with the First Marine Expeditionary Force. He was born in 1972 at the height of the Vietnam War and was baptized by his uncle, Father Patrick Boyle, S.J., a highly decorated Army Airborne chaplain back from two tours in Southeast Asia. Boyle's middle name was in honor of the late Hugh O'Connell, a former Milwaukee County district attorney and Circuit Court judge. Young Boyle was in the reserves while in Pepperdine Law School in California, being admitted to the Wisconsin bar in September, 2002. He then began work in his father's law firm, Boyle Boyle, Boyle & Paulus, joining his sister Bridget there. Two months later, he was called up and shipped out to the Middle East. He resumed his law practice in the summer of 2003. (Photo courtesy of Gerald P. Boyle.)

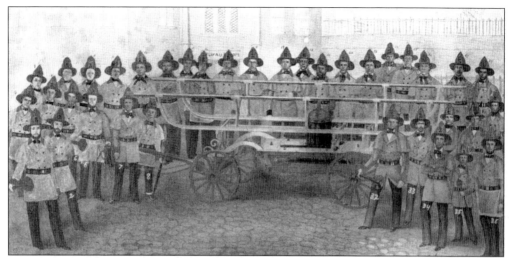

Many early volunteers in Milwaukee's first firefighting units were Germans. However, Irish also joined the ranks, serving in such units as Milwaukee Engine Company No. 1. In this sketch from 1855, the firefighters were arrayed around a water pumper built by New Yorker James Smith. (Sketch from *History of Milwaukee*, 1922, courtesy of Sheldon Solochek collection.)

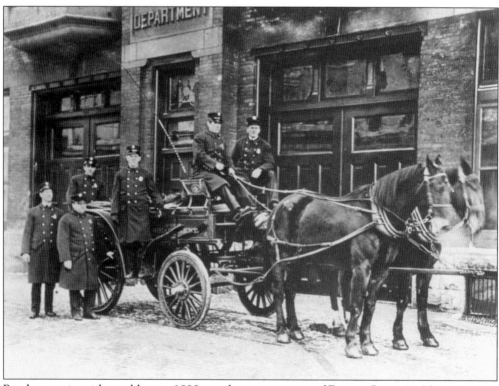

Ready to extinguish any blaze in 1898 was the pumper crew of Engine Company No. 3. Among the firefighters were pipeman Edward Haley (standing front) and Otto Bottinger (seated left), hose wagon driver. Next to him was Bernard McGinnis, assistant engineer. The others are not identified. (Photo courtesy of the Milwaukee County Historical Society.)

James Foley was chief engineer for the Milwaukee Fire Department at the turn of the previous century. Well-mustachioed, he was the epitome of the keen-eyed firefighter of Irish extraction. (Photo courtesy of the Milwaukee County Historical Society.)

Three Milwaukee firefighters wore their dress uniforms for a portrait in the 1880s. The photo identifies Officers (no first name) Haley, Otto Bottinger, and Bernard McGinnis. (Photo courtesy of the Milwaukee County Historical Society.)

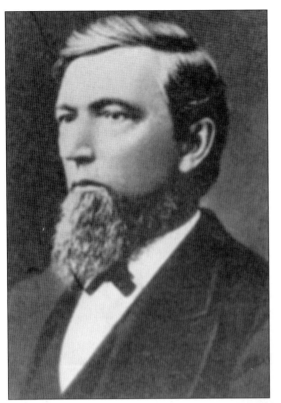

Daniel Kennedy was appointed Milwaukee's police chief in 1878, serving until 1880. Under the existing political spoils system, Democrat Kennedy immediately fired 25 patrolmen considered to be Republicans. Before his chief's slot, Kennedy earned his stripes as a "roundsman." He was in charge of other officers when they made their "rounds" of downtown. As such, Kennedy was one rank above patrolman, earning an additional five dollars each month. During his tenure, Kennedy opened a West Side police station on Walnut Street in 1879 and increased the force to 127 officers. His annual salary was about $2,000. (Photo courtesy of the Milwaukee County Historical Society.)

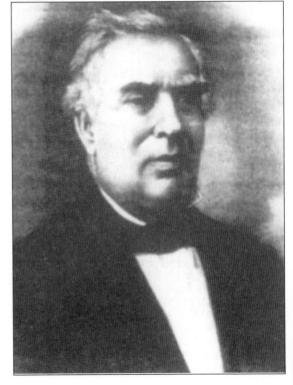

Charles Henry Larkin was elected Milwaukee County sheriff in 1860, serving a two-year term. Prior to winning his seat, he was sergeant-at-arms of the Territorial Legislative Assembly in 1845, a member of the state's second Constitution Convention and county treasurer. During bank riots in the city in the spring of 1861, Sheriff Larkin was severely injured and had to be rescued by Zouaves with drawn bayonets and loaded weapons. In another riot that autumn, a black workman was lynched in the Third Ward after a knife fight that killed an Irish laborer. When another African American was acquitted in the murder, Sheriff Clark spirited the man out of town to prevent more bloodshed. (Photo courtesy of the Milwaukee County Sheriff's Department.)

Police Officer D.J. O'Brien was resplendent with his sword, posing for a photo in the early 1900s. Patrolmen gave up their traditional gray top hats prior to 1900 and began wearing dark blue uniforms in the years before 1917. The shield as shown on O'Brien's coat replaced a star in 1903. (Photo courtesy of the Milwaukee County Historical Society.)

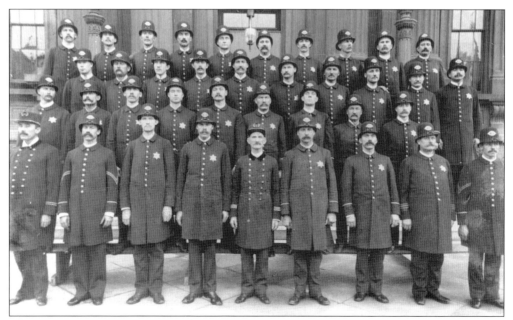

The Milwaukee Police Department's Wednesday Drill Squad stood at attention in 1896, to show off its snappy uniforms. Among the officers listed were a Boyce, Keller, Ennis, Dougherty, O'Connor, and two Flynns. (Photo courtesy of the Milwaukee County Historical Society.)

William Stanley Sullivan, a graduate of St. John's Cathedral High School in 1965, joined the Milwaukee police department in 1970. He had served a stint in the Army, based in Germany as a Specialist 5 in the artillery. As a patrol officer in 1973 and 1974, Sullivan worked undercover in the narcotics division—hence the long hair and beard. He retired as a sergeant from the force in 2000 and is historian with the Emerald Society, as well as organizing its annual golf outings. (Photo courtesy of Bill Sullivan.)

Milwaukee Police Sergeant Michael Hogan carries on the tradition of Irish Americans serving in the city's department. Here, he keeps watch during the 2003 Great Circus Parade. (Photo by John Alley, courtesy of *The Irish American Post*.)

Seven

THE SOCIETIES
GATHERING OF THE CLANS

The drums go bang, the cymbals clang and the pipes they blaze away when Milwaukee's Irish organizations gather. It's been that way for a long time. The Curran Literary Society, organized during the winter of 1866–1867, was one of the first social gatherings of young Irish "ladies and gentlemen." John E. Fitzgerald, James Pollard, Patrick Tyrrel, John Johnston, William Croke, Ellen Lynch, Jennie Murphy, and Anna and Kittie Davlin were among the initial members. After presenting several amateur plays, the group morphed into the East Side Literary Society. Seeking larger quarters, it moved to St. Gall's Hall and became—of course—the West Side Literary Society before eventually becoming the Curran Literary Society. Presidents included Richard Burke, Tom Shaughnessy, and Martin Larkin. The group also met at Curry's Hall, at the corner of the then Grand Avenue (now Wisconsin Avenue) and Second Street.

That tradition of gathering continues with the Shamrock Club of Wisconsin, which celebrated its 40th anniversary in 2000, with President Cate Harris running a tight ship. That year's Irish Rose was Mary McAndrews, with John F. (Jack) Noonan honored as Irishman of the Year. The club's first president was Pat Meylor, followed by an extended list of notable Milwaukee Irish.

Other Irish organizations in the city include the Ancient Order of Hibernians, the Emerald Society, and Irish Genealogical Society of Wisconsin, plus Celtic Women International and numerous dance groups. Many of them meet at the Irish Cultural and Heritage Center, whose first officers were Patti Garrity, Dale Brenon, Julie Smith, and Roger Walsh. A kick-off fund-raiser for the ICHC was held April 16, 1993, at Derry Hegarty's pub.

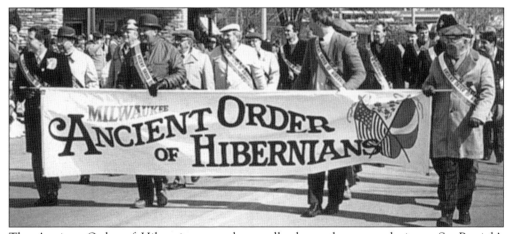

The Ancient Order of Hibernians march proudly down the street during a St. Patrick's parade sponsored by the Shamrock Club of Wisconsin. (Photo by John Alley, courtesy of *The Irish American Post.*)

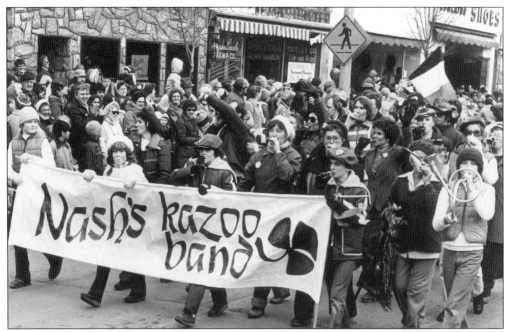

During the three decades when Kit and Josie Nash were alive and running their Irish Castle pub on Milwaukee's South Side, Nash's Kazoo Band was always a staple of any St. Patrick's Day parade. (Photo by Robert J. Higgins, courtesy of the Shamrock Club of Wisconsin.)

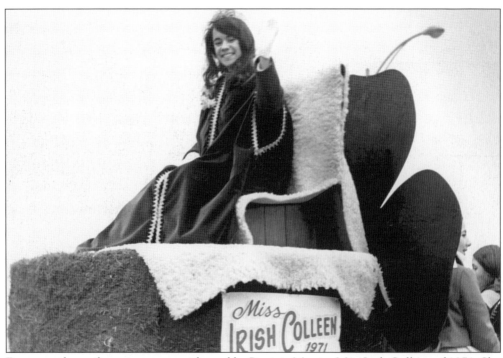

Every parade needs a princess, as evidenced by Patricia Martin, Miss Irish Colleen of 1971. She gives the royal wave from her perch in the St. Patrick's Day parade.(Photo by Robert J. Higgins, courtesy of The Shamrock Club of Wisconsin.)

Paddy's pig is a big hit in an early 1970s St. Patrick's Parade as the green-tinged procession wends its way through a chilly downtown Milwaukee. (Photo by Robert J. Higgins, courtesy of The Shamrock Club of Wisconsin.)

St. Patrick's Day always brings out the Gaelic politicians, publicans, and those who simply wish they were Irish. In this parade along West Wisconsin Avenue in the 1970s were the likes of, from left to right, Judge Michael Barron, Joe Donovan, Dan O'Connell, Father John Crowley, pub owner and Shamrock Club president (1971–1973) Derry Hegarty, Judge Christ Seraphim, Judge Hugh O'Connell (in hat), and Judge John L. Coffey. (Photo by Robert J. Higgins, courtesy of The Shamrock Club of Wisconsin.)

In 1980, photographer Bob Higgins receives the Irishman of the Year award from the Shamrock Club of Wisconsin and has a place of honor in that year's St. Pat's parade. Higgins duly recorded the Irish community's social life for several decades, making sure that the club's newsletter was filled with images of Gaels doing what they do best: helping others and having fun. (Photo courtesy of The Shamrock Club of Wisconsin.)

BOB HIGGINS
Irishman of the Year WITH HELENE COY
CAR DRIVEN BY THE GREEK MAYOR OF DELAFIELD - TED CHENTIS

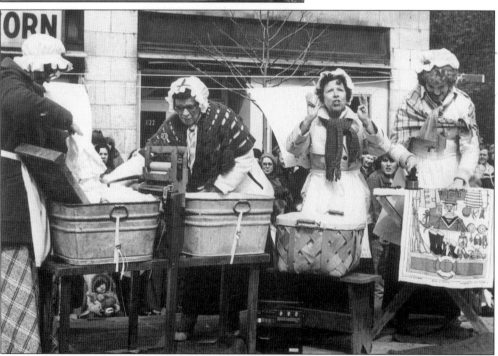

The Irish Washerwomen were a big hit in the 1980 Shamrock Club of Wisconsin's St. Patrick's Parade. Second from left was Bernice Reilly, and Julia Cain was on the far right. The others are unidentified. (Photo by Robert J. Higgins, courtesy of The Shamrock Club of Wisconsin.)

Snow along the St. Patrick's Day parade route on North Avenue in 1993 did not deter these hardy spectators from enjoying the festivities. (Photo courtesy of *The Irish American Post*.)

St. Patrick's Day is always a great time to dress up and strut the Green Stuff. Joe Pembroke (left), 1992 parade marshal, and Tom Wiseman, Irishman of the Year, were ready to march in the St. Patrick's Day Parade that year. Wiseman went on to become president of the Irish Cultural and Heritage Center board. (Photo by John Alley, courtesy of *The Irish American Post*.)

A winsome Kate Reilly helps sell goods at the Shamrock Club of Wisconsin booth during a long-ago Holiday Folk Fair. Her mother, Bernice Reilly, was the "Voice of Irish Fest" for almost 20 years, each year answering hundreds of telephoned questions prior to the event. (Photo courtesy of the International Institute of Wisconsin.)

The Irish Cottage in the Milwaukee Public Museum's ethnic village was developed with the assistance of the Shamrock Club of Wisconsin, which donated artifacts and offered ideas on their display. Club members regularly present Irish-themed programs in the museum. On hand during one such event are, from left to right, Kathy Mallon, Joe Dowling, Kathy Valent, Betty Kowalski, Irv Kowalski, Gen Farley, Jim Farley, an unidentified member, and Betty Dowling. Seated were Dennis McLaughlin and Pat Williams. (Photo courtesy of the Milwaukee Public Museum.)

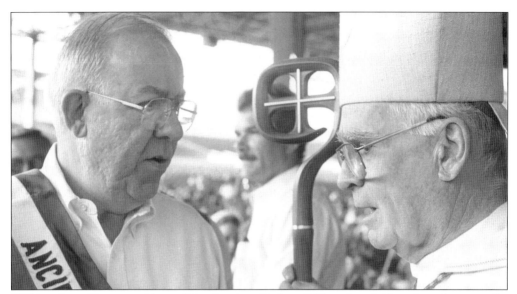

William Ryan Drew, president of the Ancient Order of Hibernians-Milwaukee chapter, talks with Bishop Edward O'Donnell of St. Louis at the 1993 Irish Fest mass. Bishop O'Donnell presided at the liturgy, always an integral part of the festival. He was the national chaplain of the Hibernians at the time. Over Drew's extended career in public service, he was a Milwaukee alderman and president of the Common Council, director of the Department of City Development and chief of staff for Milwaukee County Executive Tom Ament. (Photo by author, courtesy of *The Irish American Post*.)

The Shamrock Club of Wisconsin is ably led in the 1970s by such stalwarts as, from left to right: (back row) Joe Donovan, Bill Reilly, Marybeth Holloway, Kathleen Valent, Dan Dineen, and Bill O'Boyle; (bottom row) were Mae Feeney, Dr. John Walton, Katie Clark, and Mary Hippler. (Photo by Robert J. Higgins, courtesy of The Shamrock Club of Wisconsin.)

The Shamrock Club of the Wisconsin Color Guard participated in the 1995 Celtic Nations Heritage Festival of Louisiana. From left were Kryan Hamill, Tom Blaha, Laura Surges, Cate Harris, Kristine Carrigg, Tom Neville, Jack Noonan, Joseph Hughes, Richard Clarey, Chuck McLaughlin, Erin Neville, Patricia Tierney, Katherine Moore, Patricia Hogan, Barbara

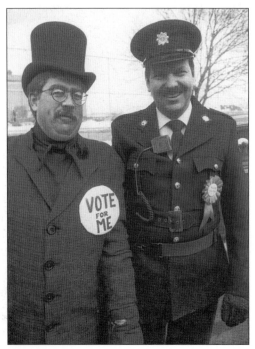

A top-hatted Mike Brady turns out the vote during the 1993 St. Patrick's Parade in Milwaukee. Keeping an eye out for any election shenanigans is "Garda officer" Tom Kennedy. (Photo by author, courtesy of *The Irish American Post*.)

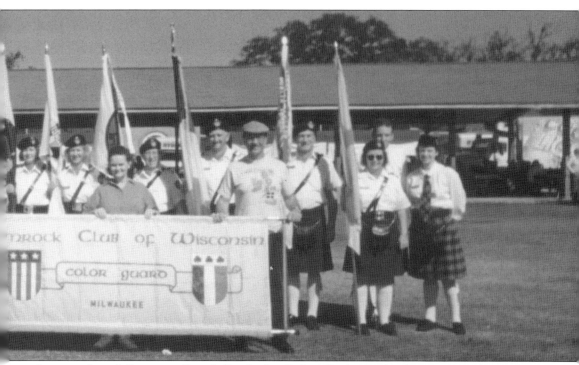

Arneson, Joseph Donovan, Joseph Pembroke, Robert Burke, Richard Tierney, Gail Neville, Allen Roling, and Katherine Higgins. (Photo courtesy of Jean Bills and the Shamrock Club of Wisconsin Color Guard.)

A check for $1,250 is presented in 1995 to Patrick V. Kessnich, director of telethon and special events for the Children's Hospital Foundation, by Tom McKale of the Emerald Society of Wisconsin. The money was donated to the hospital's Brendan Fund, named in honor of Brendan Ward, son of Irish Fest founder Ed Ward. Brendan had died of a heart problem in 1986. Over the years, the Emerald Society has given thousands of dollars to the fund through the various benefits and programs it sponsors. (Photo courtesy of *The Irish American Post*.)

Irish singer Dolores Keane (left) shared a smile with Jean Bills when the Milwaukeean visited her home in Caherlistrane in 1999. Bills is founder of the Celtic Women International, which is based in Milwaukee and holds programs and seminars throughout the year. It annually sponsors a convention drawing in participants from Irish, Welsh, Scottish, Cornish, and other Celtic heritages. (Photo courtesy of Jean Bills.)

The Irish Cultural and Heritage Center of Wisconsin is the Irish community's primary meeting and greeting spot, located at 2133 West Wisconsin Avenue near the Marquette University campus. Concerts, dance classes, weddings, films, lectures, art shows, book readings, and discussion groups are always on the ICHC agenda. The center is located in the old Grand Avenue Congregational Church, built in 1887. Its large auditorium, which once seated 1,300 persons, was the city's largest such public facility for more than sixty years after the facility was constructed. In 1986, the building was listed on the National Register of Historic Places. (Photo by author, courtesy of *The Irish American Post.*)

Eight

GET ON DOWN AND HOOLIE

Milwaukee's Irish have always been one to enjoy a Green Tie party, poem, or play. It helps if music is involved. Today's Leahy's Luck, Ceol Garde and Anam Ri have solid roots in their respective Irish genres. And it seems that Milwaukee singer/song writer Peter Mulvey spends more time performing in Dublin and Belfast than in his own backyard.

Performer/historian Martin Dowling didn't just fiddle around; he went on to become traditional music officer with the Northern Ireland Arts Council. Sigmund Snopek touches on his Irish roots with his flute solo, "A Rock in the Wicklow Mountains," and a one-hour opera *Trocaire* sung in English, Irish, and Somalian. Every once in awhile, Tom Russell blows into Milwaukee for a gig, fresh from another tour to Ireland or Norway, to the delight of local relatives and fans. His critically acclaimed *Man From God Knows Where* touches on his family's émigré heritage, leaving Templemore to settle near Milwaukee in the 1850s.

Two notable Irish American film stars were born in Milwaukee. Pat O'Brien's grandparents came from counties Galway and Cork. He was educated at Gesu School, serving mass for Father Patrick Murphy. Spencer Tracy's ancestors were from County Galway. His stage presence was noted by Broadway producer George M. Cohan, which eventually led him to the movies.

Reaching into the grab bag of history, the old Irish Fest players and Milwaukee Irish Arts are carrying of the entertainment traditions launched by John Ryan's Gaiety Theater in 1847. The Milwaukee Rep's artistic director, Joe Hanreddy, still makes sure that an O'Neill, Friel or McPherson production is somewhere in the seasonal lineup. Monty Davis, artistic director of the Milwaukee Chamber Theatre, has a mother born in Portadown, County Armagh, and his dad's family is from Tandrage.

After all, the world's an Irish stage.

The smiles were are as large and genuine as the trophy held by Katie Wright (left) and Becky Cissne, 1998 world champions in senior choreography. Both were members of the Trinity Irish Dancers, receiving the award in Dublin and celebrating in a pub later that night. Cissne started with Trinity in 1981 and now works as a Pilates instructor in Los Angeles, as well as studying voice-overs for films. Wright performs with the Trinity Dance Company. (Photo courtesy of Becky Cissne Slaske.)

Many noticeable Irish performers have appeared in Milwaukee over the years. Among them was Anglo-Irish playwright-essayist Oscar Wilde, who performed in Milwaukee on March 5, 1882. The then 27-year-old actor gave an address on decorative art to about 300 persons in the old Nunnemacher Grand Opera House where the Pabst Theater now stands on Wells Street, called Oneida Street at the time. Tickets were 25, 50, and 75 cents, with reserved seating being another quarter. Of his Milwaukee audience, Wilde was quoted in *The Milwaukee Sentinel* as saying, "I have been informed that the society of Milwaukee is very good, and that you have many wealthy, fashionable and cultured people here." While in Milwaukee, he stayed at the old Plankinton House where the Grand Avenue Mall is located today. Built in the early 1870s, the plush Nunnemacher was renamed the Stadt Theater after extensive remodling by new owner Frederick Pabst. On January 14, 1895, the Stadt was destroyed by fire and was replaced by the current Pabst Theater. The theater is now owned by Michael Cudahy, Milwaukee philanthropist and jazz fan. (Photo courtesy of the Milwaukee County Historical Society.)

Radio star Dennis Day visited Milwaukee for a St. Patrick's Day dinner and dance in 1972. Surrounded by some lovely colleens, the singer quickly got into the party mood as he signed autographs. (Photo by Robert J. Higgins, courtesy of the Shamrock Club of Wisconsin.)

Eileen Louise (Irish) O'Leary has been the exemplary voice of Irish pop and folk music in Milwaukee for several generations. This shot of her was taken at the 1981 Milwaukee Irish Fest. But her career reaches back still deeper. O'Leary was awarded the Presidential Medal of Freedom in 1946 for her musical contributions with the Red Cross during World War II. In 2003, O'Leary was also honored by Milwaukee Irish Arts for her lifetime of promoting Irish music. (Photo courtesy of Milwaukee Irish Fest.)

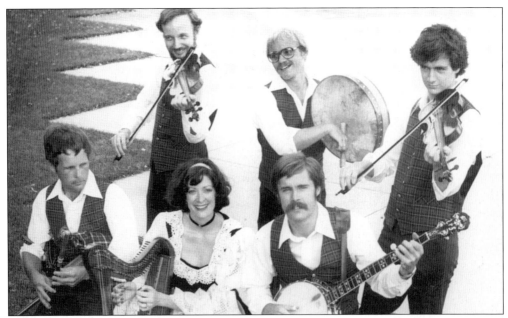

Irish musicians always are ready to perform at Holiday Folk Fair, sponsored by the International Institute of Milwaukee, Wisconsin. In 1980, entertainers include (from left) Gary Bottoni on the pipes; Patricia Williams, Miss Holiday Folk Fair 1980, with her Irish harp; and Dan Hosmanek, banjo. Standing were John Maher, fiddle; Geoffrey Keeling, bodhran; and Martin Dowling, fiddle. A total of 74,195 persons attended that year's fair. (Photo courtesy of Holiday Folk Fair, International Institute of Wisconsin.)

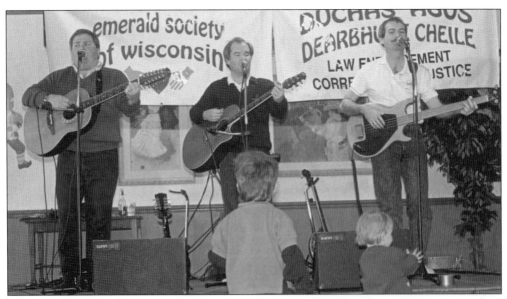

The Irish folk group Blarney performs at a Brendan Heart Fund benefit in 1993, as a couple of young dancers twirled in front of the stage. From left are Chuck Ward, Dennis Murphy, and Kevin Stapleton. The group was started by Ward's brother Ed, while a student at Marquette University. Blarney recorded several albums and still turns out for a lively tune every St. Patrick's day and at Milwaukee Irish Fest. (Photo courtesy of *The Irish American Post*.)

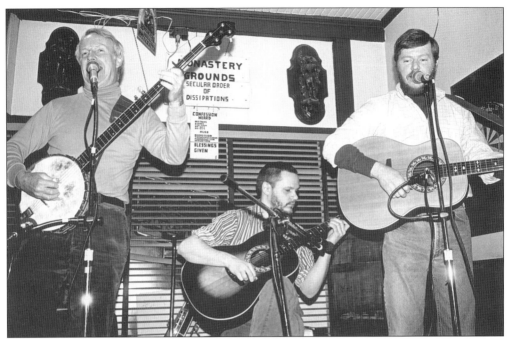

Among those in the forefront of Milwaukee's Irish music scene is Bill Crowley (left), who performs throughout the area along with Terry Sexton (right). At this gig, they were joined by Steve Wurcer for a good round of fun. Crowley and Sexton have performed together on and off since the late 1980s. (Photo by John Alley, courtesy of *The Irish American Post*.)

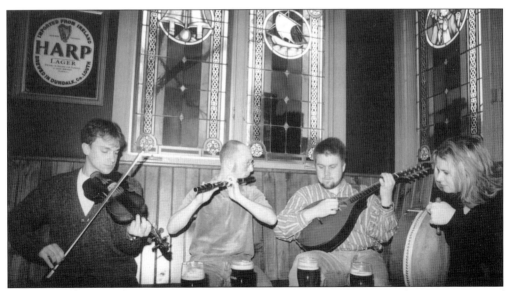

The hot Irish band of the early 1990s, 180 & the Letter G, demonstrated a creative mix of heritages. Performing at the County Clare in 1998 are, from left to right, fiddler Czech-Irish Ed Paloucek, Ukranian-Jewish flautist Brett Lipshutz, Dan Beimborn, and Marina Doyle on the bodhran. Doyle is a native of Baltinglass, County Wicklow. Paloucek, Lipshutz, and Doyle have competed in the *Fleadh Cheoil na hEireann*, Ireland's most prestigious music competition. (Photo by John Alley, courtesy of *The Irish American Post*.)

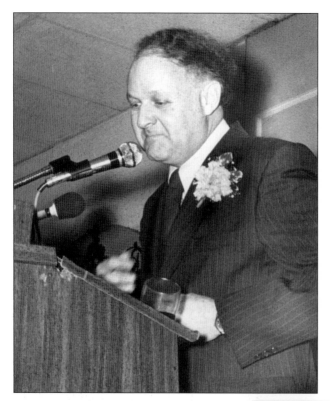

Latin teacher Donn Goodwin's passion was poetry, both as a writer and reader. For years, he edited the Shamrock Club of Wisconsin newsletter. Goodwin died in 1990 while giving a performance at Milwaukee Irish Fest. Subsequently, the festival's Donn Goodwin poetry prize is named after him. Goodwin was known for encouraging young writers, thereby ensuring the city's firm literary future. (Photo by Robert J. Higgins, courtesy of the Shamrock Club of Wisconsin.)

Poet/actor/bartender/playwright/man-about-town Denis Patrick Regan is a prolific writer on subjects ranging from James Joyce's Leopold Bloom to baseball. His works include *Last Epitaph of a Wise Man*, *Wit's Twist*, and *Will the Real Crazy Jane Please Stand Up*, the latter a spoof on William Butler Yeats. His grandfather, Daniel Regan, came to Milwaukee from Ireland in 1912 and worked in the city's Humboldt Yards railroad center. Regan's dad, Patrick, was a gas company meter reader who "was full of jokes," his proud son recalls. Regan's sister Erin and brother Michael have regularly appeared in his plays. (Photo by author, courtesy of *The Irish American Post*.)

Dublin-born Jim Liddy (left) is a professor of creative writing at the University of Wisconsin-Milwaukee, honored in 2001 for a lifetime of creativity with an international symposium of Irish and Irish American writers. Liddy grew up in Coolgreany, County Wexford. He practiced law in Ireland before taking up poetry, first being published in *The Irish Times* in 1959. Here, Liddy shares a round of pints with a poet friend, the late Sean Lucey, at the old Black Shamrock pub. (Photo by author, courtesy of *The Irish American Post*.)

Chicago-native Joe Gahagan was a creative writing instructor at the University of Wisconsin-Milwaukee and a widely published author and poet. His works regularly appeared in publications both Stateside and internationally. Before his death in 2002, Gahagan co-ordinated the annual poetry readings at the Milwaukee Irish Fest Hedge School. The festival's Joseph Gahagan Memorial Prize is now awarded to the best poem by a Wisconsin resident. (Photo courtesy of *The Irish American Post*.)

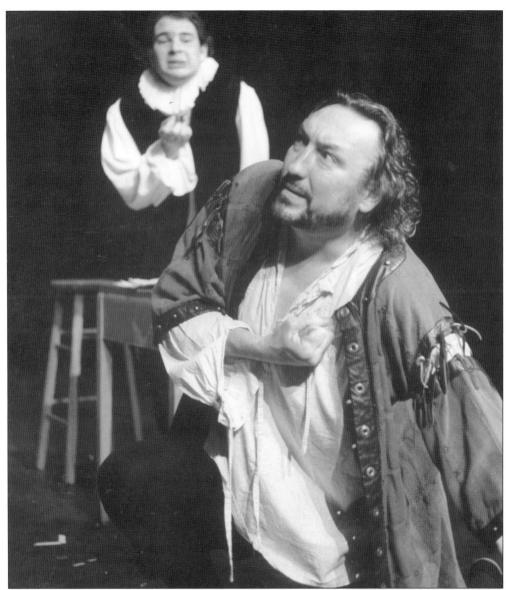

Mike Neville (foreground) puts in a dramatic performance as Richard Burbage in his *The Virgin Queen*, a play presented at Milwaukee's Stemke Theatre in 1995. In the background was Jonathan West, demonstrating appropriate angst. Neville's works have been presented at venues from off-Broadway to Seattle. One of his most popular works is *Decent Ordinary Criminals*, a play delving into the souls of two thugs in Northern Ireland swept into in a money-raising scam dreamed-up by an American visitor. His radio voice characters for the award-winning *Hotel Milwaukee* on Wisconsin Public Radio include Dr. Ivan Poodnik and Admiral Topgallant. In his play, *Lamps*, Neville plays an additional 18 roles, including that of a three-legged dog. Among his many other parts, Neville has starred as the dead grandma in *Flanagan's Wake*. Descended from a long line of Milwaukee Irish, he graduated in 1968 from Marquette University with a bachelor's degree in journalism. Neville has been awarded a Schubert fellowship in playwriting and was invited by Edward Albee to participate in one of the famed playwright's writing workshops. (Photo courtesy of Maureen Kilmurray.)

Nine

THE TINKER'S BAG

The Irish are everywhere in Milwaukee, from playing hurley to promoting peace. They love family reunions, circuses, and dressing up to party. The Gaels were not always welcome in the city, however. The process of assimilation was downright hard and sometimes perilous. There were clashes between the native and foreign-born. Sometimes it was because of differences in religion. Other challenges involved customs. In the early days of the city, the America-for-Americans "Know-Nothing" movement in the city was of some concern as it spread to the Midwest from the East Coast.

But as the Irish gradually were absorbed into the general population, the nativist movement disappeared. In fact, by 1920, there were 110,068 foreign-born in Milwaukee. Of that number, only 1,447 were from Ireland, a figure already well-behind the Germans at 39,576 and the 23,060 Poles. Yet while fewer in numbers, the Irish still maintained strength within their own community and were also happy to share their vitality and creativity with the rest of the population. After all, everyone is Irish on St. Patrick's Day.

The Shamrock Club hurley team clicks their ash sticks after a match on the Milwaukee lakefront. The team is one of eight in the Milwaukee Hurling Club. Other league teams are sponsored by McBob's, Hanley's, The Harp, Derry's, Axel's, County Clare, and the Milwaukee Ale House. The hurling club was launched in 1996. (Photo by author, courtesy of *The Irish American Post*.)

Every Irish community needs a leprechaun, or two . . . or more. John McMahon was always an integral part of the city's St. Patrick's Day parades. Joanne Demster was a regular leprechauness at many early Irish Fests. Not all the wee creatures need to be totally green. In 1999, Michael Brown, raised in Milwaukee's North Meadows housing complex, became the University of Notre Dame's first African American leprechaun mascot. (Photos by Robert J. Higgins, courtesy of the Shamrock Club of Wisconsin.)

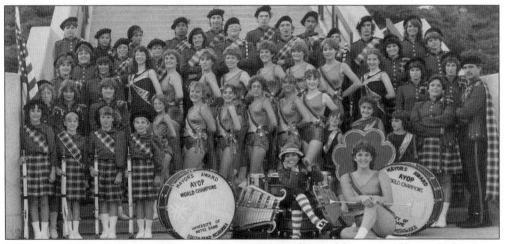

The senior Daley Debutantes Baton & Drum Corps, directed by sisters Sherry Daley Jung, Marcy Daley Blaufuss and Patti Daley Wertschnig, always put on an award-winning performance wherever and whenever they strutted their stuff. In addition to its numerous St. Patrick's Day appearances in Milwaukee over the years, the group has participated in all the Milwaukee Irish Fests and marched in the 1999 and 2003 St. Patrick's Day parades in Dublin, Ireland. In the last 40 years, the group has also marched in 38 of the Chicago St. Pat's parades. The group was launched in 1955. (Photo courtesy of The Daley Debutantes.)

When it comes to circuses, Charles Philip (Chappie) Fox knows his llamas . . . and his elephants, acrobats and tents. He was instrumental in the growth of the Circus World Museum at Baraboo, Wisconsin, and was its director for 13 years. Teaming with the Schlitz Brewery and promotions pal Ben Barkin, Fox initiated the Great Circus Parade in Milwaukee. The annual event still draws thousands of spectators. Coming from an illustrious clan originating in County Offaly, Fox was born in 1913, grew up in Milwaukee and died in 2003. (Photo courtesy of the Circus World Museum.)

Between 1904 and 1911, this marvelously ornate band wagon toured with the one-ring Belfast-based Royal Hanneford Canadian Circus. From 1919 until it was acquired by the Circus World Museum in 1998, the wagon lay crumbling on an estate in England. Milwaukeean John Burke sponsored its recovery and renovation. It is now an integral part of the Great Circus parade International section. (Photo courtesy of the Circus World Museum.)

The Russell-Malloy Family Reunion was held at the River Hills home of Dr. Tom Russell on August 19, 2000. The gathering is held regularly every few years, attracting family members of all ages from around the world. From left to right are: (first row, seated on the ground) Christopher Curran, Taed Russell Cejtin, Mikael Russell Cejtin, Sam Russell Cejtin, Will Russell Cejtin, Mary Catherine Culton, Emily Jacobs, Sarah Culton, Andrew Culton, Maggie Culton, Michael Starr, Logan Krivitz, Colin Krivitz, Sean Krivitz, Kyle Krivitz, Quinn Krivitz, and Emy Fay Albert; (second row, seated and kneeling on the ground) Paul West, Avicia West, Meghan Russell Duffie, Julianne Russell Cejtin, Patrick Duffie, Drew Russell (hidden), John Paul Russell, Russell Fay, Scott Albert, Ian Russell, Micah Russell, Annette Dugenske, and JoAnne Fay Albert holding Reilly Rose Albert; (third row, seated on chairs) Elizabeth Russell Beer, Mary Russell Kenyon, Paul Anderson, Ellen Anderson Counts, Kay Anderson, Jim Anderson, Bob Russell, Alice Russell Bill Russell, Katherine Russell, James Lowell Russell, Jack Russell, Gerry Russell, Gert Russell Hintz, Pat Malloy, Justin Malloy, Edmund Russell, Elaine Russell, Fr. Dominic Scheerer, and Mary Barnett Jacobs; (fourth row, standing behind chairs) Margaret Fay, Katie Russell Collins, Fran Russell, Tom Collins, Judy Collins, Mary Collins Cook, Tony Cook, Don Troudt, Mary Francis Fay Troudt, Dick Albert, Ellen Fay Fadel, Dan Fay, Mary Russell Curran, Faith Russell, Jim Curran, Colleen Russell Duffie, Mike McKeown, John Miller, Mary Catherine Russell, Jim Russell, Harriet Russell, Tom Russell, Joseph Russell, Karryn Mapes holding Nicole Mapes, Maureen Russell, Barbara Burns Fehse, Bob Fehse, Martin Hintz, Ron Schlitt, Jean Schlitt, John Spielmann, Patrick Russell, Stephanie Rusell, Joan Curry Sontag, Lizbeth Jacobs holding Charlie Jacobs, and Tom Jacobs; (back row) John Cook, Tammer Yousef Fadel, Abbas Fadel, Ashraf James Fadel, Morrad Fadel, Salim Fadel, Allish Barcelo, Brendan Barcelo, Dennis Russell, Pat Russell Arenas, John J. Russell, Marilee Russell Fuss, Lorene Barnett, Charlie Barnett, Terry Culton, Helen Culton, Douglas Starr holding JoHannah Grace Starr, Catherine Starr, and Michael T. Jacobs. (Photo courtesy of Dr. Tom Russell.)

Jeanne McCue is a nurse and humanitarian, named the first Irish Rose of the Shamrock Club of Wisconsin in 1973. She is also the recipient of the 2003 Humanitarian Award from the Milwaukee Academy of Medicine for her work in providing aid to refugee camps, orphanages, and home hospices in Croatia and Bosnia. Often under fire, she has made more than twenty trips to the Balkans, carrying medical supplies and other necessities to the war-torn region. McCue is a registered nurse at Froedert Hospital. (Photo courtesy of Jean Bills.)

A group of Vietnam War protesters known as the Milwaukee 14 sang as they burned draft records in downtown Milwaukee on September 25, 1968. From left to right are Jerry Gardner, Robert Graf, James H. Forest, Father Lawrence Rosebaugh, Brother K. Basil O'Leary, Jon Higgenbotham, Donald Cotton, Father James W. Harney, Father Alfred J. Janicke, Frederick J. Ojile, Michael D. Cullen, Father Anthony J. Mullaney, Father Robert J. Cunnane, and Douglas Marvey. All were jailed in the incident in which they took the records from a nearby Selective Service office and set them on fire. (Photo courtesy of *The Milwaukee-Journal Sentinel*.)

In 2000, Irish-born activist and deacon Michael D. Cullen participates in an annual dialogue in Milwaukee on African and Celtic Spirituality. In the turbulent '60s, Cullen was one of the founders of Milwaukee's Casa Maria shelter through the Catholic Worker movement and was deported in 1973 after participating in draft protests. While back in Ireland, he founded the Emmanuel House of Providence. He currently is a deacon at several small parishes in northern Wisconsin. (Photo by John Alley, courtesy of *The Irish American Post*.)

Ten

MOTHER OF ALL FESTIVALS
MILWAUKEE IRISH FEST

Milwaukee's Irish Fest grew out of discussions among members of the Irish community who wished to highlight the community's Gaelic music, dance, drama, sports, and culture. It was decided that a festival would be the best means to showcase national and regional Irish talent, as well as to provide a stage for up-and-coming local performers.

Under the direction of Ed Ward, a local attorney and member of the Irish folk group Blarney, months of planning went into the first festival, which kicked off in 1981. Skull sessions were held around the city, most notably in Margaret O'Donoghue's Mr. Guinness, a West Side pub known for its good pints and *craic*. Almost immediately, the festival received world-wide attention for the scope of its cultural and musical programming.

The Smithsonian Institution's national folk life program called Milwaukee Irish Fest "the largest and best Irish cultural event in North America." Other reviewers termed the event "The Gentle Festival" and "The Family Festival." It was also selected as one of the Top 100 Tour Attractions in North America by the American Bus Association.

Thousands of volunteers of all ages and walks of life still contribute to making the event an annual success. A committed board and area organizers ensure that the management of the festival remains strong.

Milwaukee Irish Fest attracts visitors from around the United States and from numerous foreign countries. In 2003, the event entertained almost 130,000 persons. It also remains one of the most innovative of all the city's many great ethnic festivals. In 1982, it initiated summer lodging packages, working with the Wisconsin Innkeepers Association. In 1987, the Milwaukee Irish Fest Summer School was launched at the University of Wisconsin-Milwaukee, providing a week of intense lectures, workshops, and demonstrations on all things Irish.

The festival was the also first to offer admission promotions that ranged from donating canned goods to aid area food pantries to recycling. Irish Fest literally became "The Green Festival" with its Greenwish Village environmental displays; the LepreCan Collection Clan, youngsters who picked up recyclables from vendors; and its aluminum can collection program in co-ordination with the USS Division of USX Corporation.

All this demonstrates that Milwaukee Irish is a good community neighbor, as well as an international player on the cultural front. The Irish spirit of creative sharing and caring continues to shine.

The Milwaukee Irish Fest Center houses the festival's offices, the John J. Ward music archives, and a hall for lectures and concerts. The building, a refurbished Masonic temple, is located at 1532 Wauwatosa Avenue, in the western Milwaukee suburb of Wauwatosa. (Photo courtesy of Milwaukee Irish Fest.)

Such crowds as seen here at the 1989 Milwaukee Irish Fest are common as visitors come from around the world to see top flight entertainment, theater, sports, and exhibits. (Archival photo courtesy of *The Irish American Post*.)

In 1981, Milwaukee Mayor Henry Maier signs a proclamation announcing the first Milwaukee Irish Fest. The festival was to be held along Lake Michigan, on a permanent entertainment area sprawling over more than 80 acres used by Summerfest and other outdoor musical events. Below, the mayor holds up a poster for the festival as fiddler John Maher performs a tune to benefit the television cameras and other media attending the signing. (Photos courtesy of Milwaukee Irish Fest.)

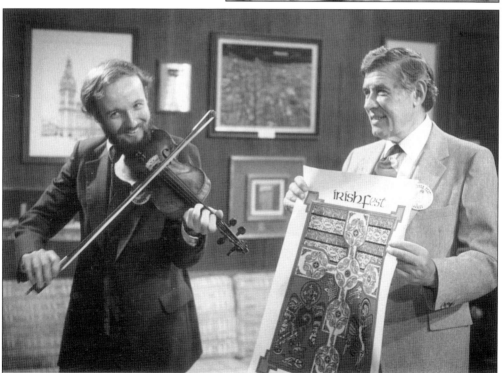

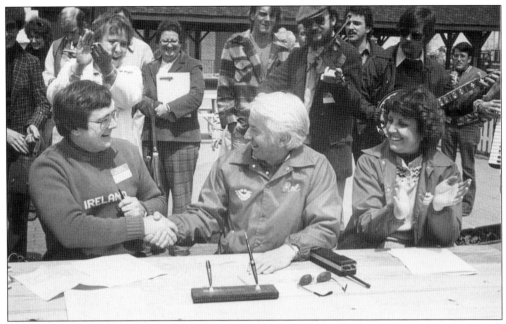

There are handshakes, clapping and smiles all around in 1981 as Milwaukee Irish Fest representatives sign the grounds contract with Summerfest management. Seated are, from left to right, Ed Ward, the festival's executive director; Rod Lanser, Summerfest director; and Kris Martinsek, grounds manager. Lighting a cigarette in the background is John Carroll. Wildly applauding is Lorraine Murphy, as John Maher fiddles and Dan Hosmanek plays the banjo. (Photo by author, courtesy of Milwaukee Irish Fest.)

The 1993 executive committee of Milwaukee Irish Fest includes, from left to right: (seated) Jane Walrath, assistant treasurer; Barb Tyler, secretary; Jane Anderson, executive director; and Colleen Kennedy, vice president; (standing) Ann Kerns, president; and Tom Barrett, treasurer. (Photo by author, courtesy of *The Irish American Post.*)

An ancient Gaelic horn is blown to announce the coming of Milwaukee Irish Fest in 1989, as civic leaders paint a green strip eastward along Chicago Street to the main gate. (Photo by author, courtesy of Milwaukee Irish Fest.)

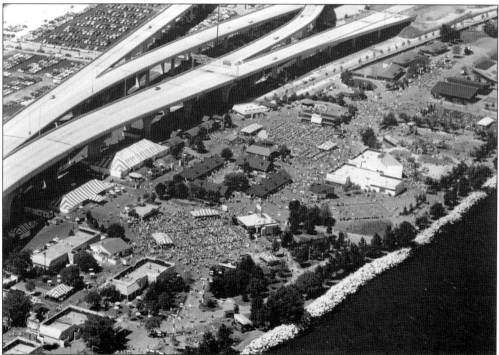

An aerial shot of Milwaukee Irish Fest in 1985 shows the extent of the crowds meandering the lakefront festival site. Lake Michigan is in the lower right corner. (Photo by Jeff J. Voelz, courtesy of Milwaukee Irish Fest.)

Milwaukee wakes up one morning in 1990 to find Jonathan Swift's Gulliver character "asleep" on Bradford Beach, allegedly washed ashore overnight. Shortly after this halcyon scene, media flocks to the lakefront as Lilliputians, musicians, and Irish Fest volunteers gathered around for a fun morning. Police, alerted in advance, keep long lines of gawking motorists moving slowly along the lakefront as they crane to take a look. Gulliver then becomes a staple landmark on the festival grounds throughout the 1990s, as the gathering place for family and friends. The promotion is one of many successful attention-getting activities and events that created interest and spurred attendance. (Photo by author, courtesy of Milwaukee Irish Fest.)

Dublin-native John Gleeson helped link Irish cultural organizations and individuals with Irish Fest throughout its growing years. He went on to assist in organizing the Center for Celtic Studies at the University of Wisconsin-Milwaukee and became a senior lecturer in ethnic studies with an emphasis on Irish language, Irish history, Irish-American history, and film. (Photo by author, courtesy of *The Irish American Post*.)

The booking of the Galway-based De Dannan—led by fiddler Frankie Gavin—and numerous other headliners in 1981 is a major coup for the first Milwaukee Irish Fest. From that initial event to the present day, fans flock to see such major entertainers. Just about anybody who is anybody in Irish music—from traditional to rock and Irish jazz—has appeared at the festival. Lineups over the years included The Chieftains, Natalie McMaster, Tommy Makem, Liam Clancy, Carmel Quinn, Dennis Day, the Tannahill Weavers, Schooner Fare, Gaelic Storm, Stockton's Wing, Patrick Ball, Altan, Storm, Mick Moloney, Battlefield Band, Leahy, La Bottine Souriante, Omagh Choir, Liz Carroll, the Clumsy Lovers, Arcady, the McPeakes, Mary Black, Dublin City Ramblers, and dozens more. (Photo courtesy of Milwaukee Irish Fest.)

Paddy and Molly McFest, the long-time mascots of Milwaukee Irish Fest, dated for four years before deciding to tie the wedding knot in 1985. The "ceremony" is held with much hilarity in the St. Pius XI gym and roller rink. The wedding party including Muriel Crowley, Ed Ward, and Joe Donovan. (Photo by author, courtesy of Milwaukee Irish Fest.)

There's always fun at Milwaukee Irish Fest, as witnessed by these winners of the 1995 Potato Olympics. The games are organized by Dan DeWeerdt (kneeling, left front). One of the judges is Ald. Mike Murphy (standing far right). Paddy McFest is aided by the potato mascot of the Wisconsin Potato & Vegetable Growers Association, an event sponsor. (Photo by author, courtesy of Milwaukee Irish Fest.)

Involving amateur musicians in workshops, lectures and programs has long been a tradition at Milwaukee Irish Fest. This session, led by notable performer Derek Bell, harpist from the Chieftains, is held atop the Park East Hotel. The Irish Fest Summer School also features major entertainers and scholars who lead classes in fiddle, flute, bodhran and dance. (Photo by author, courtesy of Milwaukee Irish Fest.)

Kids, kids, kids everywhere. This 1989 gathering of the Cashel-Dennehy Irish Dancers at Milwaukee Irish Fest occurs well before the popularity of *Riverdance* and *Lord of the Dance*. In 1982, renowned dance instructor Dennis Dennehy becomes the group's teacher. Since 1993, daughter Kathy Dennehy has been Cashel's dance master. In 1998, Kate Walrath, one of the first students of the school, earns her teaching certification. (Archival photo courtesy of *The Irish American Post*.)

Milwaukee Irish Fest cultural displays are integral to expanding the knowledge and understanding of the Gaelic world. Displays range across the board from this 1987 exhibit on cottages to prize-winning photos drawn from the Irish Press Photographers' annual media competition. The cultural tent, located on the far south end of the lakefront grounds, is always a popular draw. (Photo by author, courtesy of Milwaukee Irish Fest.)

The Gathering of the Clans, each year featuring a different "tribe" such as the Mangans, brings in families from around the world to Milwaukee Irish Fest. A special area is set aside for the honored group, where shirt-tail relatives can meet, greet and make new acquaintances. A featured position in the daily Irish Fest parades is part of the excitement. (Archival photo courtesy of *The Irish American Post*.)

126

The tug-of-war is one of several athletic competitions that attracts fans to Milwaukee Irish Fest. The sanctioned events pit brawn against brawn with international teams competing for prizes and adulation. There's always a lot of grunting and groaning as the ropes are pulled tight and the competitors dig in as in this 1989 match. (Archival photo courtesy of *The Irish American Post*.)

What if they gave a festival and it rained . . . and rained . . . and rained? Well, it doesn't matter much when it is Milwaukee Irish Fest—at least during the Big Flood of 1987, a "soft weekend" that even Noah would have loved. Sixty thousand die-hard music lovers hung around throughout the extended downpour, helping the beer tents do a booming business. This spectator sticks it out to watch the action at the Scots-Irish sing off. (Photo by John Alley, courtesy of Milwaukee Irish Fest.)

SUGGESTED READING

Anderson, Harry H. "The Jeremiah Curtin House," *Milwaukee History: The Magazine of the Milwaukee County Historical Society*, 1983, pp. 2–28.

—. "Jeremiah Curtin's Boyhood in Milwaukee County," *Milwaukee History: The Magazine of the Milwaukee County Historical Society*, Summer, 1990, pp. 54–67.

Bruce, William George, ed. History of Milwaukee. Vols. I, II, III. Chicago: The S.J. Clarke Publishing Co. 1922.

Carroon, Robert G. "John Gregory and Irish Immigration to Milwaukee," *Milwaukee History: The Magazine of the Milwaukee County Historical Society*, 1989, pp. 2–14.

Conzen, Kathleen Neils. *Immigrant Milwaukee: 1836–1860*. Boston: Harvard University Press. 1979.

Cudahy, Michael. *Joyworks: The Story of Marquette Electronics*. Milwaukee: Milwaukee County Historical Society. 2002. 236 pp.

Eagle, John. "Baron Thomas Shaughnessy: The Peer That Made Milwaukee Famous," *Milwaukee History: The Magazine of the Milwaukee County Historical Society*, 1983, 28–40.

—, ed. *History of Milwaukee*. Madison: Western Historical Association, 1881. 1663 pp.

—, ed. *The Irish American Post*, www.irishamericanpost.com; archives at the Golda Meir Library, University of Wisconsin-Milwaukee

Gurda, John. *The Making of Milwaukee*. Milwaukee: Milwaukee County Historical Society. 1999. 468 pp.

Kennedy, Joseph. *The Cudahys: An Irish-American Success Story*. Milwaukee: Michael J. Cudahy. 1995. 127 pp.

Quinn, Brenda W., and Ellen D. Langill. *Caring for Milwaukee: The Daughters of Charity at St. Mary's Hospital*. Milwaukee: Milwaukee Publishing Co. 1998. 112 pp.

Watrous, Jerome A., ed. *Memoirs of Milwaukee County*. Vol. II. Madison: Western Historical Association. 1909. 1007 pp.

Wells, Robert W. *This is Milwaukee*. Garden City, N.Y.: Doubleday & Co., 1970. 277 pp.

A love of all things Irish is evidenced in the gleeful looks of pals Paul Hoffman and Dan Hintz at the first Milwaukee Irish Fest in 1981. Hoffman, whose mother's family are Robinsons from England and Howes from County Cork. Hintz became a writer for *Irish Music Magazine* and a film critic for *The Irish American Post*, besides working for other publications. He currently is an art consultant. Hintz's great-great-grandfather, Patrick Russell, emigrated from Templemore, County Cork, in 1839. (Photo courtesy of Milwaukee Irish Fest.)